Cool Restaurants Istanbul

teNeues

Imprint

Editors: Zeynep Subaşi, Rosina Geiger

Photos: Gavin Jackson

Introduction: Zeynep Subaşi

Layout & Pre-press: Katharina Feuer, Jan Hausberg, Kerstin Graf

Imaging: Jan Hausberg

Translations: SAW Communications, Dr. Sabine A. Werner, Mainz
Dr. Suzanne Kirkbright (English), Nina Hausberg (English/recipes), Brigitte Villaumié (French),
Carmen de Miguel (Spanish), Maria-Letizia Haas (Italian)

Produced by fusion publishing GmbH, Stuttgart . Los Angeles www.fusion-publishing.com

Published by teNeues Publishing Group

teNeues Book Division
Kaistraße 18
40221 Düsseldorf, Germany
Tel.: 0049-(0)211-994597-0
Fax: 0049-(0)211-994597-40
E-mail: books@teneues.de

teNeues Publishing Company
16 West 22nd Street
New York, NY 10010, USA
Tel.: 001-212-627-9090
Fax: 001-212-627-9511

teNeues Publishing UK Ltd.
P. O. Box 402
West Byfleet, KT14 7ZF
Great Britain
Tel.: 0044-1932-403509
Fax: 0044-1932-403514

teNeues France S.A.R.L.
4, rue de Valence
75005 Paris, France
Tel.: 0033-1-55766205
Fax: 0033-1-55766419

teNeues Ibérica S.L.
c/Velázquez, 57 6.° izda.
28001 Madrid, Spain
Tel.: 0034-657-132133

teNeues
Representative Office Italy
Via San Vittore 36/1
20123 Milano, Italy
Tel.: 0039-(0)347-7640551

Press department: arehn@teneues.de
Phone: 0049-2152-916-202

www.teneues.com

ISBN-10: 3-8327-9115-9
ISBN-13: 978-3-8327-9115-5

Bibliographic information published by Die Deutsche Bibliothek.
Die Deutsche Bibliothek lists this publication in the Deutsche Nationalbibliografie;
detailed bibliographic data is available in the Internet at http://dnb.ddb.de.

Average price reflects the average cost for a dinner main course without beverages. Recipes serve four.

Contents

Page

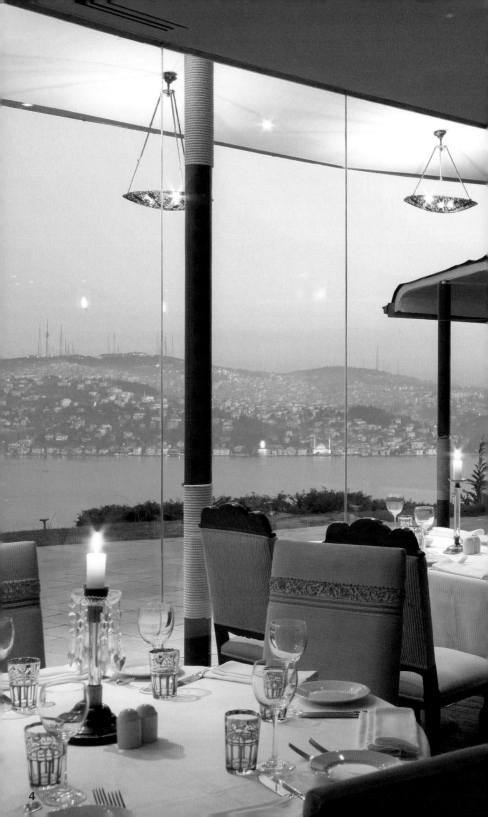

Introduction

There are only a few cities in the world where you can simultaneously experience the modernity of the West and the mystery of the East. Istanbul, the city on two continents, is one of them. Istanbul's rich history represents many different cultures, which make it one of today's top destinations. Past and future meet not just in the city in itself, but also in its restaurants.

The modern and minimalist look of *Changa*, set in a century-old building, impresses visitors as much as locals. In the heart of this busy city, you can relax in the tranquil and traditional restaurants like *Hacı Abdullah*, *Balıkçı Sabahattin* or *Pandeli*. Additional highlights are the impressive panoramic view of the Bosporus and the old city's legendary silhouette, which you can enjoy from many of these restaurants like *Mikla* and *Vogue*.

All you have to do is decide what sort of meal you would enjoy at what time of day. In almost all restaurants, you will experience a calm ambience during the daytime. But I have to warn you: these places can be totally different after sunset and every evening they are transformed into the city's nightlife hotspots.

Unlike many other cities, Istanbul's restaurants have different seasonal opening hours. For example, if you were to visit *Lokanta* and *Wan-na*, two of the hippest spots in the city, during the summertime, they would be closed. But don't worry, *Ulus 29*, *Sunset Grill & Bar* or *müzedechanga* are ready to welcome you to their open-air terraces or gardens, where you can reach out and dip your hand in the Bosporus.

The book you are holding right now lets you try out Istanbul's delicacies at home. In addition to the exquisite aroma of Turkish cuisine, you can sample the various culinary arts. Of course, it is not enough to capture the whole flavor of this city, but at least it might be a start.

Zeynep Subaşı

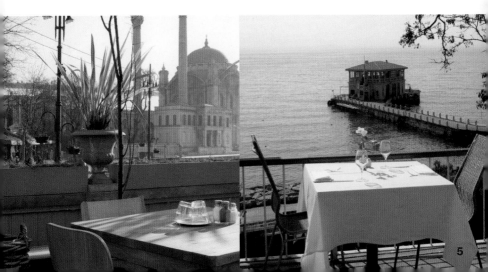

Einleitung

Es gibt nur wenige Städte auf der Welt, in denen man gleichzeitig die Modernität des Westens und das Geheimnis des Ostens erfahren kann. Istanbul, die Stadt auf zwei Kontinenten, ist eine von ihnen. Die durch ihre reiche Geschichte bedingte kulturelle Vielfalt macht Istanbul heute zu einem der angesagtesten Reiseziele. Nicht nur in der Stadt an sich, auch in den Restaurants verbinden sich Vergangenheit und Zukunft.

Das moderne und minimalistische Aussehen des *Changa*, das sich in einem hundert Jahre alten Gebäude befindet, beeindruckt Besucher wie Einheimische. Mitten in der geschäftigen Stadt finden Sie Entspannung in den ruhigen und traditionellen Restaurants *Hacı Abdullah*, *Balıkçı Sabahattin* oder *Pandeli*. Das eindrucksvolle Bosporus-Panorama und die sagenhafte Silhouette der Altstadt, die man von vielen dieser Lokale, wie dem *Mikla* und dem *Vogue*, aus sehen kann, sind zusätzliche Höhepunkte.

Allein, man muss sich in dieser lebendigen Stadt entscheiden, welche Mahlzeit man zu welcher Tageszeit zu sich nehmen möchte. In fast allen Restaurants wird man am Tag eine gelassene Atmosphäre erleben. Aber ich muss Sie warnen: Diese Orte können nach Sonnenuntergang völlig anders sein und sich jeden Abend in Zentren des Nachtlebens verwandeln. Anders als in vielen anderen Städten haben die Lokale in Istanbul zu verschiedenen Jahreszeiten unterschiedlich geöffnet. Wenn man beispielsweise das *Lokanta* und das *Wan-na*, zwei der angesagtesten Plätze in der Stadt, im Sommer aufsucht, wird man vor verschlossenen Türen stehen. Aber keine Angst, im *Ulus 29*, dem *Sunset Grill & Bar* oder dem *müzedechanga* wird man Sie auf Terrassen oder in Gärten willkommen heißen, von denen aus Sie Ihre Hand in den Bosporus eintauchen können.

Mit dem Buch, das Sie gerade in Händen halten, können Sie die Genüsse Istanbuls auch zu Hause probieren. Neben dem erlesenen Aroma der türkischen Küche werden Sie Beispiele verschiedener Kochkünste kennen lernen. Sicherlich ist das nicht genug, um den ganzen Geschmack der Stadt einzufangen, aber es könnte immerhin ein Anfang sein.

Zeynep Subaşi

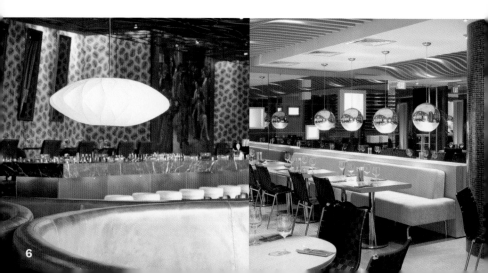

Introduction

Il y a peu de villes au monde où se côtoient la modernité de l'occident et les mystères de l'orient. A cheval sur deux continents, Istanbul est l'une d'elles. Grâce à sa diversité culturelle, née d'une histoire particulièrement riche, Istanbul est aujourd'hui une des destinations les plus en vue. Passé et futur s'y mêlent, pas seulement dans la ville même, mais aussi dans les restaurants.

L'aspect moderne et minimaliste du *Changa*, situé dans un bâtiment centenaire, impressionne les visiteurs aussi bien que les autochtones. Au cœur de l'ambiance affairée de la ville, vous trouverez la détente dans des restaurants tranquilles et traditionnels tels que *Hacı Abdullah*, *Balıkçı Sabahattin* ou *Pandeli*. Le panorama impressionnant sur le Bosphore et la fabuleuse silhouette de la vieille ville que l'on peut observer de nombreux établissements comme le *Mikla* et le *Vogue*, sont des points forts supplémentaires.

Déjà, dans cette ville très vivante, il faut décider quel repas l'on souhaite prendre, et à quelle heure. Dans presque tous les restaurants, le jour, il règne une atmosphère détendue. Mais je vous préviens: ces mêmes lieux peuvent changer du tout au tout après le coucher du soleil et devenir tous les soirs les points de rencontre de la vie nocturne. Contrairement à de nombreuses autres villes au monde, les restaurants d'Istanbul ont des plages d'ouverture différentes selon les saisons. Si l'on veut aller, par exemple, l'été, au *Lokanta* et au *Wan-na*, deux des restaurants les plus en vogue de la ville, on trouvera portes closes. Mais soyez sans crainte, au *Ulus 29*, au *Sunset Grill & Bar* ou au *müzedechanga*, on vous accueillera sur des terrasses ou dans des jardins d'où vous pourrez pratiquement tremper la main dans le Bosphore.

Le livre que vous tenez maintenant entre les mains vous permettra de goûter aux délices d'Istanbul à la maison. En plus des arômes délicats de la cuisine turque, vous ferez connaissance avec des exemples d'autres talents culinaires. Bien sûr, cela ne suffira pas à saisir toute la saveur de la ville, mais ce pourrait être un bon début.

Zeynep Subaşi

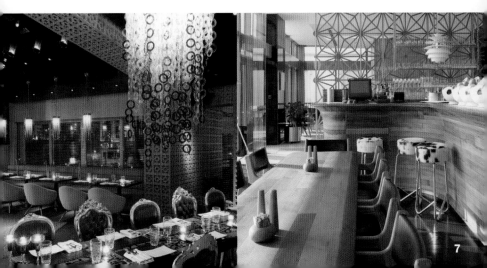

Introducción

Existen pocas ciudades en el mundo en las que se pueda respirar la modernidad de Occidente y el misterio de Oriente a la vez. Estambul, metrópoli entre dos continentes es una de ellas. La diversidad cultural consecuencia de su densa historia convierte hoy a Estambul en uno de los destinos más sugerentes. Pero no sólo en la ciudad, sino también en sus restaurantes se funden pasado y futuro.

La apariencia moderna y minimalista de *Changa*, ubicado en un edificio de cien años fascina tanto a visitantes como a residentes. En el corazón de la agitada urbe se encuentra la serenidad entorno a los tradicionales y tranquillos restaurantes *Hacı Abdullah*, *Balıkçı Sabahattin* o *Pandeli*. El impresionante panorama que ofrece el Bósforo y la legendaria silueta del casco antiguo son otros de los espectáculos a disfrutar en locales como *Mikla* y *Vogue*.

En esta ciudad palpitante hay que decidir a qué hora se toma qué comida. En casi todos los restaurantes durante el día se vive un ambiente relajado. Pero, ¡cuidado! Al caer la noche estos lugares se pueden transformar convirtiéndose en el centro de la vida nocturna. Al contrario que en otras ciudades, en Estambul los restaurantes varían el horario de apertura según las estaciones. Si por ejemplo desea ir en verano al *Lokanta* o al *Wan-na*, dos de los más conocidos de la ciudad, se encontrará con la puerta cerrada. Pero que no cunda el pánico, porque el *Ulus 29*, *Sunset Grill & Bar* o *müzedechanga* abrirán terrazas y jardines desde donde casi podrá sumergirse en el Bósforo.

El libro que tiene entre sus manos le dará la posibilidad de catar los encantos de Estambul también desde casa. Junto a los aromas de la cocina turca aprenderá diversos artes culinarios. Pero si bien esto no basta para captar el sabor de la ciudad al completo, sin duda podría ser el comienzo.

<div align="right">

Zeynep Subaşi

</div>

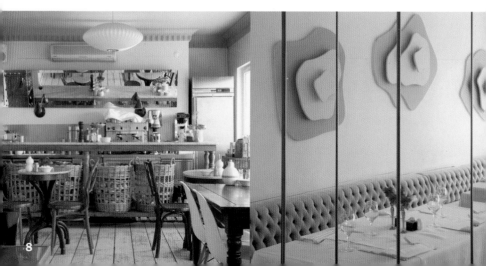

Introduzione

Esistono solo poche città al mondo in cui la modernità occidentale incontra il fascino misterioso dell'Oriente. Una di queste è Istanbul, la città a cavallo tra due continenti. La sua molteplicità culturale, conseguenza di innumerevoli vicende storiche, fa oggi di Istanbul una delle destinazioni più ambite, un luogo in cui il legame tra passato e futuro si avverte non solo nella città in sé, ma anche nei ristoranti.

L'ambiente moderno e minimalista del *Changa*, situato in un edificio centenario, attrae sia i turisti sia gli abitanti della città. Nel mezzo dell'attiva vita cittadina, ristoranti tradizionali e tranquilli come l'*Hacı Abdullah*, il *Balıkçı Sabahattin* o il *Pandeli* sono autentiche oasi di relax. Il fantastico panorama del Bosforo e la bellissima silhouette della città vecchia, visibili da molti locali come il *Mikla* e il *Vogue*, costituiscono un'attrattiva in più.

La sola decisione che bisogna prendere in questa città così dinamica è quale pasto prendere, e a che ora. Durante il giorno, in quasi tutti i ristoranti domina un'atmosfera rilassata. Ma attenzione: ogni sera, dopo il tramonto, questi ritrovi possono assumere un aspetto completamente diverso, diventando il centro della vita notturna. A differenza di quanto accade in tante altre città, i locali di Istanbul hanno orari di apertura diversi secondo le stagioni. In estate, per esempio, sono chiusi due dei ritrovi più in voga, il *Lokanta* ed il *Wan-na*. Ma niente paura: l'*Ulus 29*, il *Sunset Grill & Bar* o il *müzedechanga* accolgono gli ospiti in terrazze o giardini dai quali è possibile toccare le acque del Bosforo.

Grazie a questo libro, il lettore potrà gustare anche a casa propria le squisitezze di Istanbul. Oltre al delizioso aroma della cucina turca, egli potrà apprendere anche altri tipi di arte culinaria. Ciò non basterà sicuramente a cogliere tutto il sapore di questa città, ma è senza dubbio un buon inizio.

Zeynep Subaşi

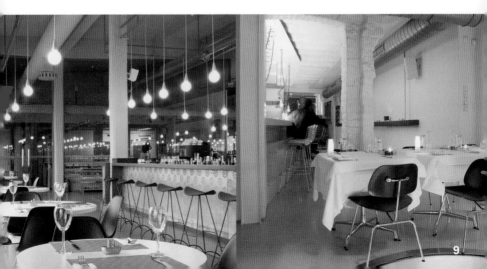

360 Istanbul

Design: Emir Uras | Chef: Mike Norman
Owners: Emir Uras, Mike Norman, Murat Koray, Sashah Khan

İstiklal Caddesi 311/32 | 80600 Istanbul | Beyoğlu
Phone: +90 212 251 1042
www.360istanbul.com
Opening hours: Everyday noon to 4 am
Average price: 25 YTL
Cuisine: Eclectic world cuisine
Special features: View of old Istanbul and the Bosporus

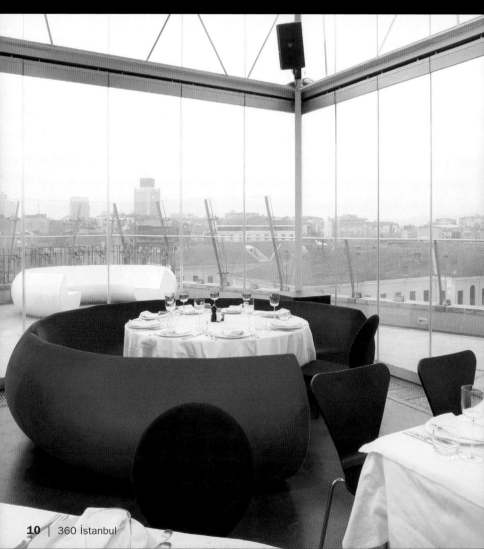

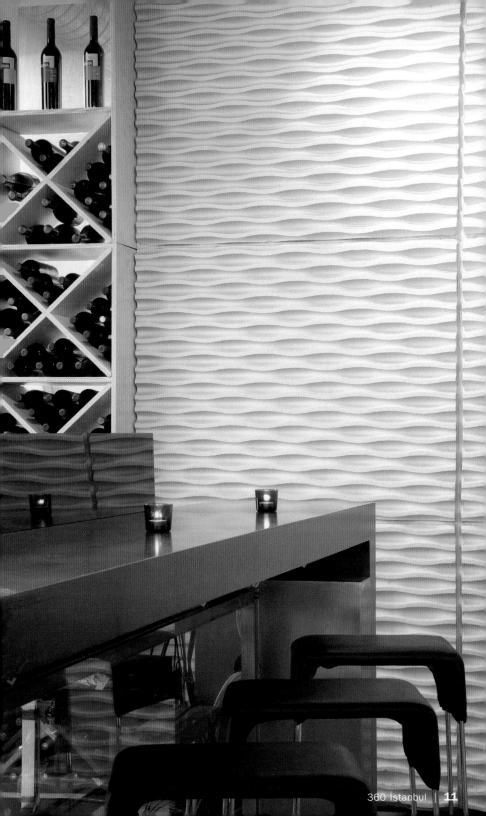

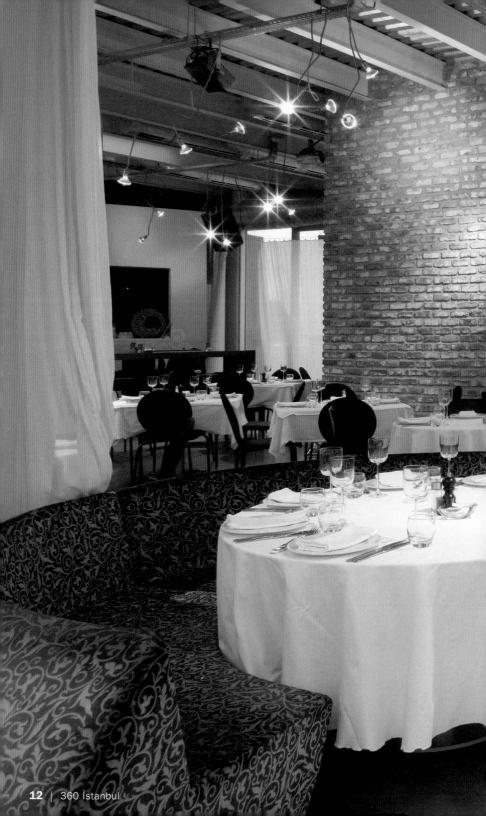

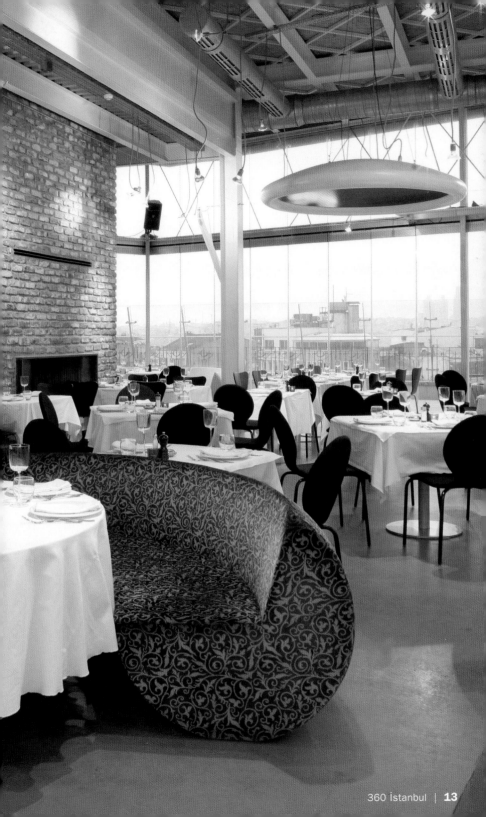

A'jia Restaurant & Bar

Design: Reşit Soley | Chef: Yener Özden
Owner: Istanbul Doors Restaurant Group

Çubuklu Caddesi 72 | 34805 Istanbul | Kanlıca
Phone: +90 216 413 9300
www.ajiahotel.com
Opening hours: Everyday 7 am to 2 am
Average price: 30 YTL
Cuisine: Italian, Mediterranean
Special features: Restaurant at the hotel A'jia

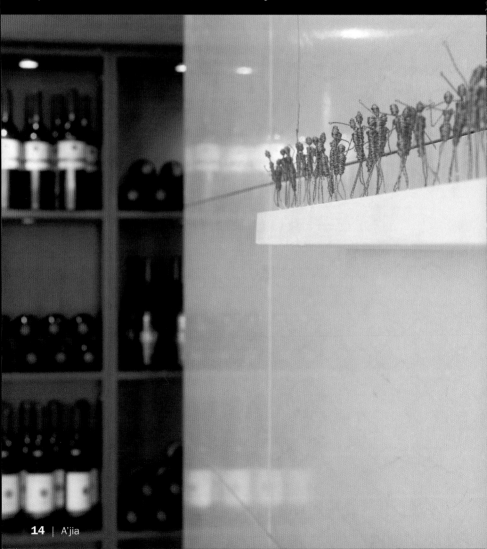

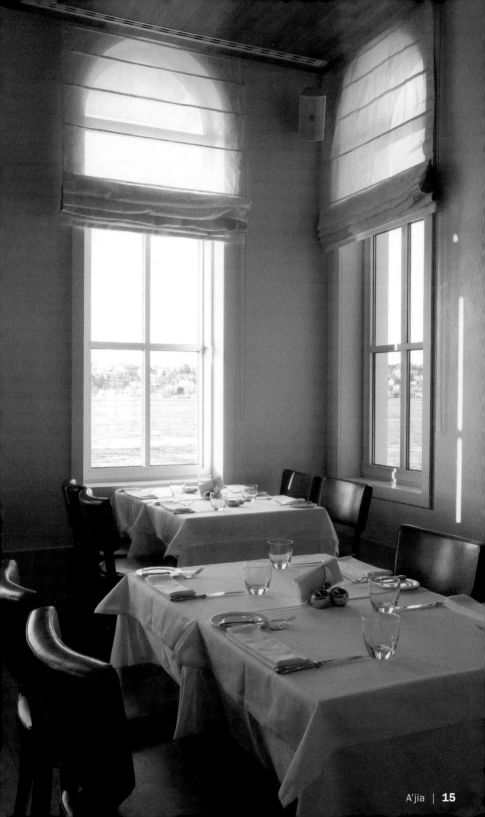

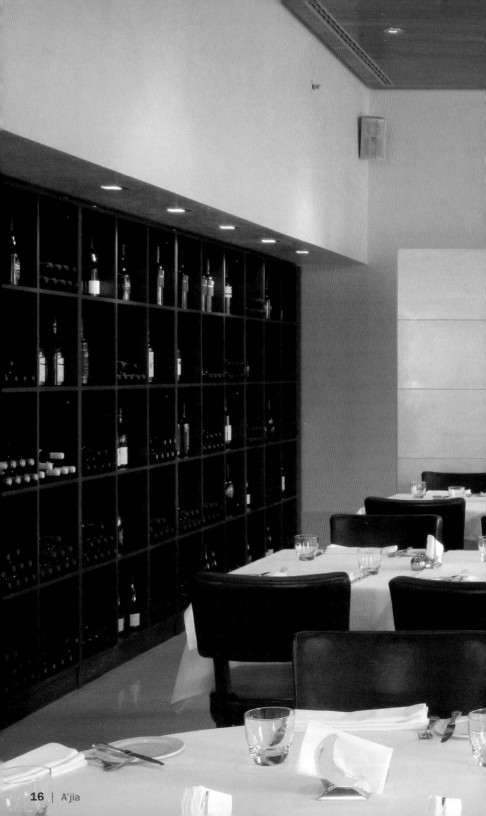

Grilled Artichokes

Gegrillte Artischocken
Artichauts grillés
Alcachofas a la plancha
Carciofi alla griglia

8 artichokes
Juice of 1 lemon
4 fennels
Vinegar and olive oil to marinate
2 bunches sea fennel
3 ½ oz mixed lettuce
4 cherry tomatoes, quartered
Salt, pepper

Onion sauce
200 ml olive oil
2 fennel, cleaned and diced
2 onions, diced
4 tbsp wine vinegar
2 tbsp mustard
Salt, pepper

Clean the artichokes and place the artichoke bottoms immediately in lemon water. Season with salt and pepper and place on a grill for 2 minutes on each side. Set aside. Wash and prepare the fennel and quarter, marinate with vinegar, olive oil, salt and pepper and wrap in aluminum foil. Cook for approx. 8 minutes in boiling water until tender. Cook the sea fennel in salted water until tender, pluck in pieces, let cool down and marinate with the lettuce in 4 tbsp onion sauce. For the onion sauce, sauté the fennel and the onions in little olive oil, deglaze with vinegar and season. Cook until soft, then mix in a blender with the leftover oil and mustard. Season again, if necessary. To arrange, stack the salad mix alternately with two artichoke bottoms on each plate. Place one quartered fennel and one cherry tomato around it and drizzle with the leftover onion sauce.

8 Artischocken
Saft von 1 Zitrone
4 Fenchel
Essig und Olivenöl zum Marinieren
2 Bund Meerfenchel
100 g gemischter Salat
4 Kirschtomaten, geviertelt
Salz, Pfeffer

Zwiebelsauce
200 ml Olivenöl
2 Fenchel, geputzt und gewürfelt
2 Zwiebeln, gewürfelt
4 EL Weinessig
2 EL Senf
Salz, Pfeffer

Die Artischocken putzen und die Artischockenböden sofort in Zitronenwasser legen. Salzen und pfeffern und auf dem Grill von beiden Seiten für je 2 Minuten grillen. Beiseite stellen. Die Fenchelknollen putzen und vierteln, in Essig, Olivenöl, Salz und Pfeffer marinieren und in Aluminiumfolie wickeln. In kochendem Wasser ca. 8 Minuten gar kochen. Den Meerfenchel in gesalzenem Wasser bissfest garen, in Stücke zupfen, abkühlen lassen und zusammen mit dem Salat in 4 EL Zwiebelsauce marinieren. Für die Zwiebelsauce den Fenchel und die Zwiebeln in etwas Öl anschwitzen, mit dem Essig ablöschen und würzen. Weichkochen lassen, dann mit dem restlichen Öl und Senf im Mixer pürieren. Evtl. noch einmal abschmecken. Zum Anrichten die Salatmischung abwechselnd mit je zwei Artischockenböden auf jeden Teller stapeln. Jeweils einen geviertelten Fenchel und eine Kirschtomate herumlegen und mit der restlichen Zwiebelsauce beträufeln.

8 artichauts
Le jus de 1 citron
4 fenouils
Vinaigre et huile d'olive pour faire mariner
2 bottes de fenouil de mer
100 g de salade mélangée
4 tomates cerises en quartiers
Sel, poivre

Sauce à l'oignon
200 ml d'huile d'olive
2 fenouils nettoyés, en dés
2 oignons en dés
4 c. à soupe de vinaigre de vin
2 c. à soupe de moutarde
Sel, poivre

Nettoyer les artichauts et déposer tout de suite les fonds dans de l'eau citronnée. Saler et poivrer et faire griller chaque côté sur le grill pendant 2 minutes. Réserver. Laver les bulbes de fenouil, les couper en quartiers, les faire mariner dans du vinaigre, de l'huile d'olive, du sel et du poivre et les envelopper dans une feuille d'aluminium. Les cuire à cœur dans de l'eau bouillante pendant env. 8 minutes. Faire cuire le fenouil de mer al dente dans de l'eau salée, le mettre en morceaux, laisser refroidir et faire mariner avec la salade dans 4 c. à soupe de sauce à l'oignon. Pour la sauce à l'oignon, faire revenir le fenouil et les oignons dans un peu d'huile, déglacer au vinaigre et assaisonner. Faire cuire à cœur et réduire en purée avec le reste de l'huile et la moutarde dans le mixeur. Rectifier éventuellement l'assaisonnement. Dresser chaque assiette en alternant des couches de salade mélangée et deux fonds d'artichaut. Disposer de part et d'autre un quartier de fenouil et une tomate cerise et napper avec le reste de la sauce à l'oignon.

8 alcachofas
Zumo de 1 limón
4 bulbos de hinojo
Vinagre y aceite de oliva para marinar
2 ramilletes de hinojo marino
100 g de lechuga variada
4 tomates cereza cortados en cuartos
Sal y pimienta

Salsa de cebolla
200 ml de aceite de oliva
2 bulbos de hinojo limpios y troceados
2 cebollas picadas
4 cucharadas de vinagre de vino
2 cucharadas de mostaza
Sal y pimienta

Limpiar las alcachofas y meter inmediatamente los fondos de alcachofa en agua con limón; salpimentarlos y cocinarlos a la plancha duran-te 2 minutos por cada lado; dejarlos aparte. Limpiar los bulbos de hinojo y cuartearlos. Marinarlos con vinagre, aceite de oliva, sal y pimienta y envolverlos en papel de aluminio. Cocerlos en agua hirviendo durante 8 minutos aprox. Cocer el hinojo marino en agua con sal hasta que esté al dente, cortarlo en trozos, dejarlos enfriar y marinarlos junto con la lechuga y 4 cucharadas de salsa de cebolla. Para hacer la salsa de cebolla sofreír el hinojo y la cebolla en un poco de aceite, rociarlos con el vinagre y sazonarlos. Cocer la mezcla hasta que esté blanda y a continuación pasarla por la batidora con el resto del aceite y mostaza. Si es necesario, condimentar de nuevo. Colocar en cada plato dos fondos de alcachofa formando una torreta, alternando una capa de lechuga y un fondo de alcachofa. Disponer alrededor un bulbo de hinojo en cuartos y un tomate cereza y rociar con la salsa de cebolla restante.

8 carciofi
Il succo di 1 limone
4 finocchi
Per la marinata: aceto e olio d'oliva
2 mazzetti di finocchio marino
100 g di insalata mista
4 pomodori pachini tagliati in quattro
Sale, pepe

Salsa di cipolle
200 ml di olio d'oliva
2 finocchi puliti e tagliati a dadini
2 cipolle tagliate a dadini
4 cucchiai di aceto di vino
2 cucchiai di senape
Sale, pepe

Pulire i carciofi e immergerne subito i fondi in acqua e limone. Salarli, peparli e grigliarli da entrambe le parti per 2 minuti. Metterli da parte. Pulire e tagliare in quattro i bulbi di finocchio, marinarli in aceto, olio d'oliva, sale e pepe, quindi avvolgerli in un foglio di alluminio e cuocerli in acqua bollente per circa 8 minuti. Cuocere al dente il finocchio marino in acqua salata, spezzettarlo, lasciarlo raffreddare e marinarlo insieme all'insalata in 4 cucchiai di salsa di cipolle. Per la salsa di cipolle: rosolare il finocchio e le cipolle in un poco d'olio, bagnare con l'aceto e condire. Lasciarli appassire, quindi frullarli insieme al resto dell'olio e alla senape. Eventualmente, regolare il condimento. Al momento di servire, alternare a strati in ciascun piatto l'insalata mista e due fondi di carciofi. Disporvi attorno un finocchio tagliato in quattro ed un pomodoro pachino e pillottare con il resto della salsa di cipolle.

Balıkçı Sabahattin

Chef & Owner: Sabahattin Korkmaz

Seyit Hasan Kuyu Sokak 50 | 34122 Istanbul | Sultanahmet
Phone: +90 212 458 1824
balikcisabahattin@hotmail.com
Opening hours: Everyday 11 am to 1 am
Average price: 25 YTL
Cuisine: Seafood

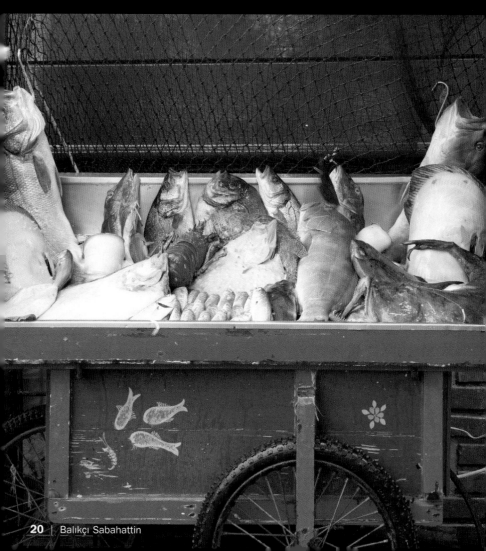

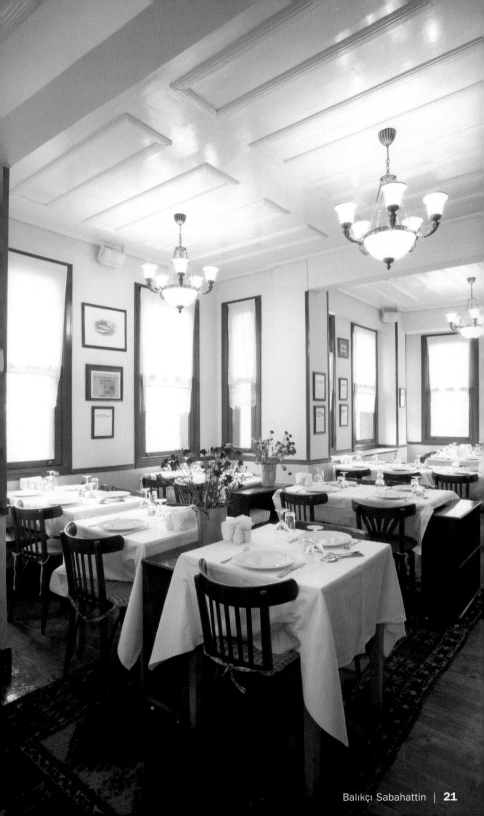

Rice with
Blue Mussels

Reis mit Miesmuscheln

Riz aux moules bleues

Arroz con mejillones

Riso con cozze

4 tbsp olive oil
4 oz butter
2 onions, diced
3 carrots, diced
2 tbsp currants
2 tbsp pine nuts
1 bunch dill, chopped
1 bunch parsley, chopped
1 bunch mint, chopped
1 tsp paprika powder
1 tsp cumin, ground
Salt, pepper
1 l water
250 ml white wine
1 lb 1 ½ oz rice
50 blue mussels, cooked and shelled

Heat oilve oil and butter in a large pot, sauté onions, carrots, currants and pine nuts, add the herbs and spices and sauté for 10 minutes. Deglaze with water and white wine and add the rice. Let simmer for 20 minutes, until the rice is done, then place the blue mussels on top and heat up. Stir once and season again with salt and pepper.

4 EL Olivenöl
120 g Butter
2 Zwiebeln, gewürfelt
3 Karotten, gewürfelt
2 EL Korinthen
2 EL Pinienkerne
1 Bund Dill, gehackt
1 Bund Petersilie, gehackt
1 Bund Minze, gehackt
1 TL Paprikapulver
1 TL Kreuzkümmel, gemahlen
Salz, Pfeffer
1 l Wasser
250 ml Weißwein
500 g Reis
50 Miesmuscheln, gekocht und ausgelöst

Olivenöl und Butter in einem großen Topf erhitzen, Zwiebeln, Karotten, Korinthen und Pinienkerne darin anschwitzen, die Kräuter und Gewürze zugeben und 10 Minuten andünsten. Mit Wasser und Weißwein ablöschen und den Reis zugeben. 20 Minuten leise köcheln lassen, bis der Reis gar ist, dann die Miesmuscheln oben auflegen und erwärmen. Einmal durchrühren und nochmals mit Salz und Pfeffer abschmecken.

4 c. à soupe d'huile d'olive
120 g de beurre
2 oignons en dés
3 carottes en dés
2 c. à soupe de raisins de Corinthe
2 c. à soupe de pignons de pin
1 bouquet d'aneth haché
1 bouquet de persil haché
1 bouquet de feuilles de menthe hachées
1 c. à café de paprika en poudre
1 c. à café de cumin en poudre
Sel, poivre
1 l d'eau
250 ml de vin blanc
500 g de riz
50 moules bleues, cuites et décortiquées

Réchauffer l'huile d'olive et le beurre dans un grand faitout, y faire sauter les oignons, les carottes, les raisins de Corinthe et les pignons de pin, ajouter les herbes et les épices et faire revenir 10 minutes. Mouiller avec l'eau et le vin blanc et ajouter le riz. Laisser frémir 20 minutes jusqu'à ce que le riz soit cuit, puis verser les moules dessus et réchauffer. Tourner une fois pour mélanger et assaisonner de sel et de poivre.

4 cucharadas de aceite de oliva
120 g de mantequilla
2 cebollas picadas
3 zanahorias troceadas
2 cucharadas de pasas
2 cucharadas de piñones
1 ramillete de eneldo picado
1 ramillete de perejil picado
1 ramillete de menta picada
1 cucharadita de pimentón
1 cucharadita de cominos molidos
Sal y pimienta
1 l de agua
250 ml de vino blanco
500 g de arroz
50 mejillones cocidos y sin cáscara

Calentar el aceite de oliva y la mantequilla en una cazuela grande, sofreír en ella las cebollas, las zanahorias, las pasas y los piñones, añadir las hierbas frescas y las especias y rehogar durante 10 minutos. Rociar con agua y vino blanco y añadir el arroz. Cocinar durante 20 minutos a fuego lento hasta que esté hecho el arroz, y a continuación colocar encima los mejillones y calentarlos. Remover la mezcla una vez y salpimentar de nuevo.

4 cucchiai di olio d'oliva
120 g di burro
2 cipolle tagliate a dadini
3 carote tagliate a dadini
2 cucchiai di uvetta di Corinto
2 cucchiai di pinoli
1 mazzetto di dragoncello tritato
1 mazzetto di prezzemolo tritato
1 mazzetto di menta tritata
1 cucchiaino di paprica in polvere
1 cucchiaino di cumino macinato
Sale, pepe
1 l d'acqua
250 ml di vino bianco
500 g di riso
50 cozze bollite e sgusciate

Scaldare in una grossa pentola l'olio d'oliva e il burro, rosolarvi le cipolle, le carote, l'uvetta di Corinto e i pinoli, unire le erbe e gli aromi e lasciar rosolare per 10 minuti. Bagnare con acqua e vino bianco, quindi unire il riso. Lasciar cuocere a fuoco lento per 20 minuti finché il riso sarà cotto, disporvi sopra le cozze e riscaldare. Mescolare, salare e pepare.

Banlieue 6080

Design: Ali Türker | Chef: Gazi & Bilal Ateş
Owner: İzzet Çapa

Taşkışla Caddesi, Maçka Demokrasi Parkı Yanı 13 | 34367 Istanbul | Maçka
Phone: +90 212 231 0356
capagroup@ttnet.net.tr
Opening hours: Mon–Sat 11 am to 2 pm, 7 pm to 1:30 am, Sun 10:30 am to 3 pm
Average price: 37 YTL
Cuisine: Italian, Chinese, Argentinean
Special features: Traditional Turkish breakfast on Sundays

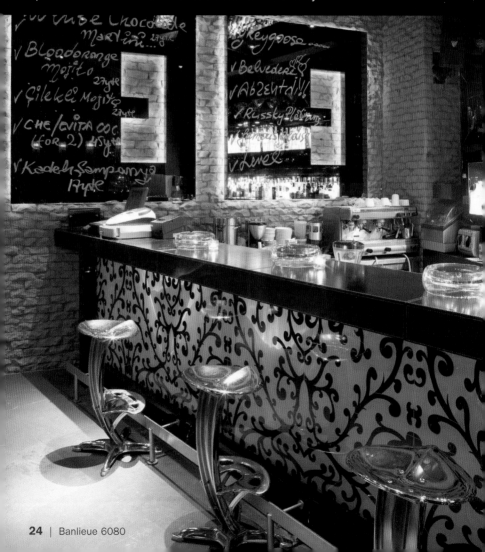

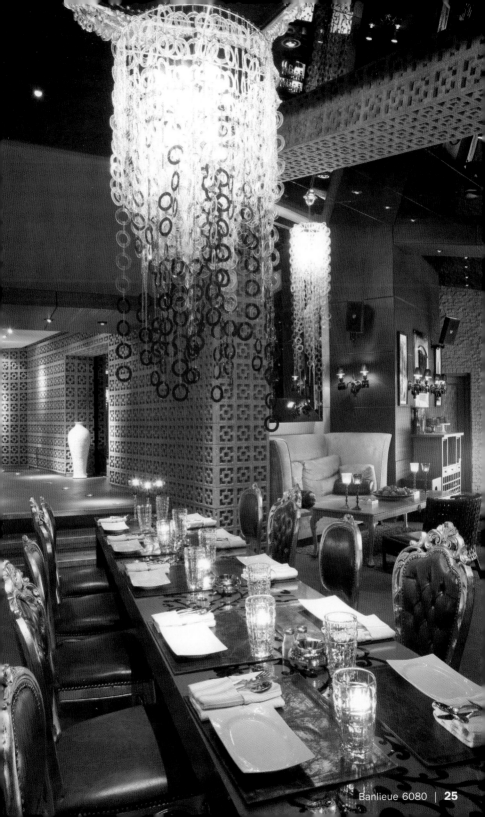

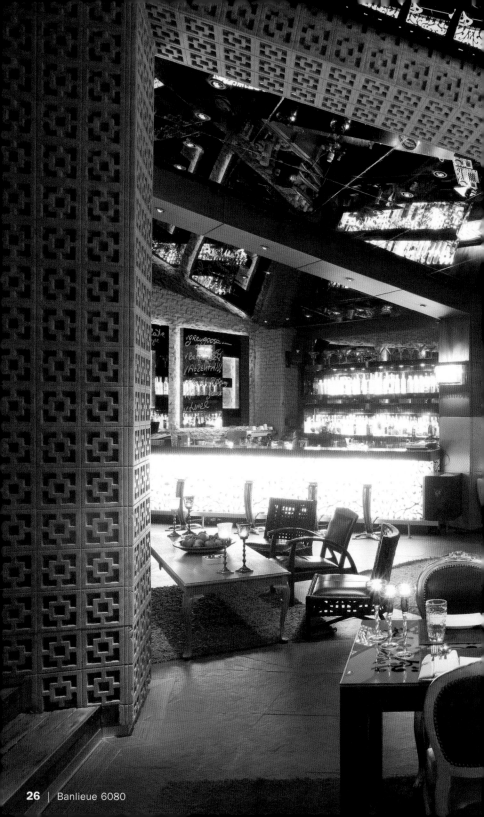

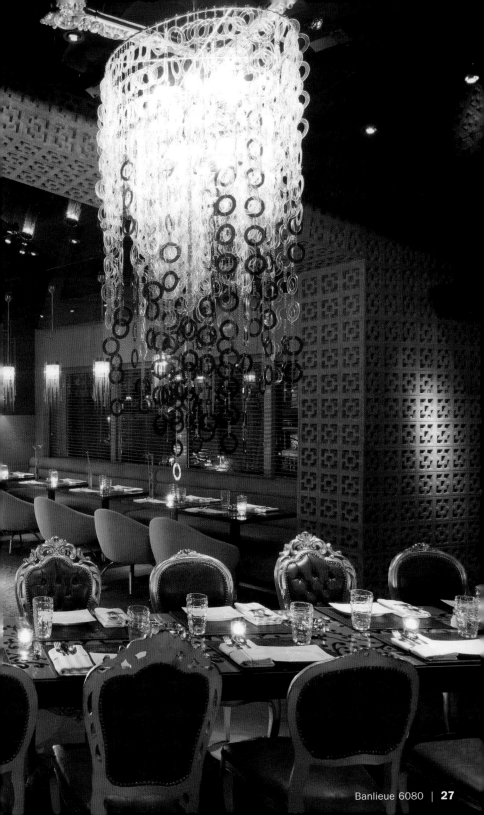

Bentley Restaurant

Design: Piero Lissoni, Nicoletta Canesi | Chef: Hasan Vural
Owner: Murat Ercan

Halaskargazi Caddesi 75 | 34367 Istanbul | Harbiye
Phone: +90 212 291 7730
www.bentley-hotel.com
Opening hours: Everyday 7 am to 10:30 am, noon to 3 pm, 7:30 pm to midnight
Average price: 20 YTL
Cuisine: International with a touch of Turkish
Special features: Private dining room

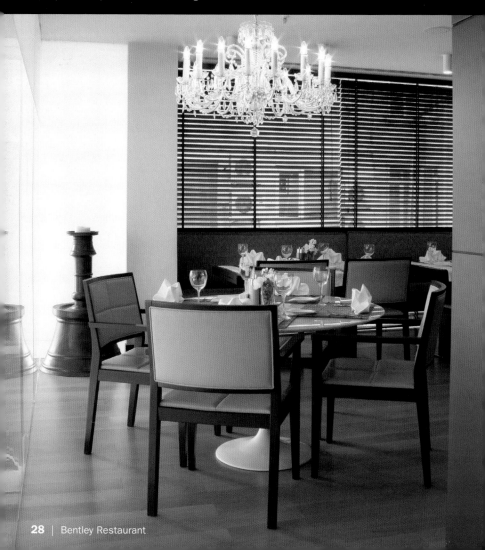

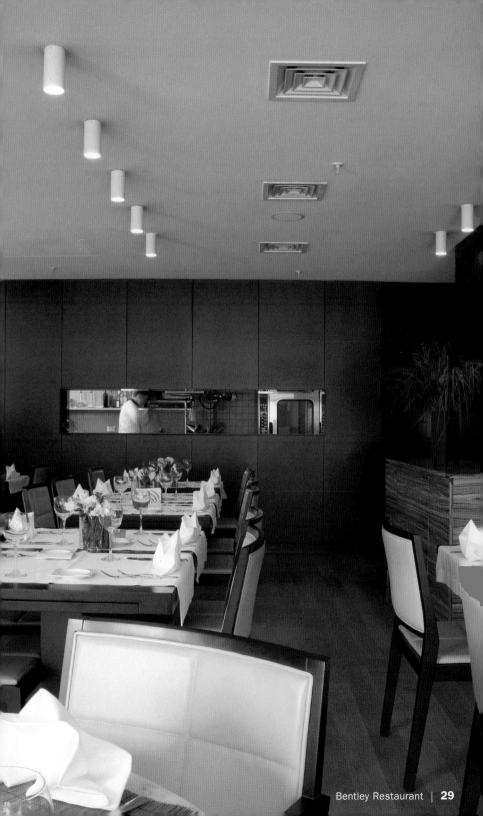

Boğaziçi Borsa Restaurant

Design: Nazlı Gönensay | Chef: Cansever Karakurt
Owner: Borsa Restaurant Group

Lütfi Kırdar Convention & Exhibition Center | 80230 Istanbul | Harbiye
Phone: +90 212 232 4201
www.borsarestaurant.com
Opening hours: Everyday noon to midnight
Average price: 50 YTL
Cuisine: Turkish

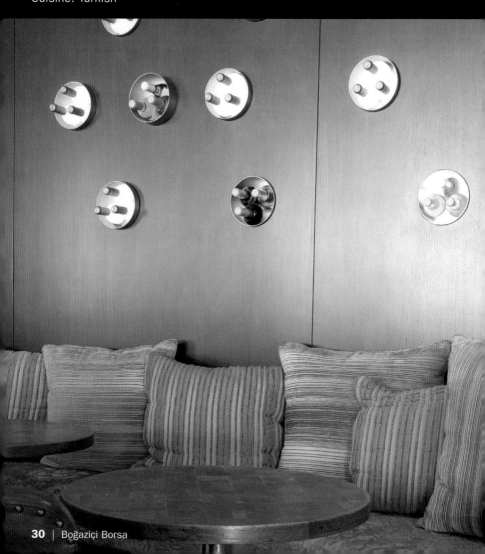

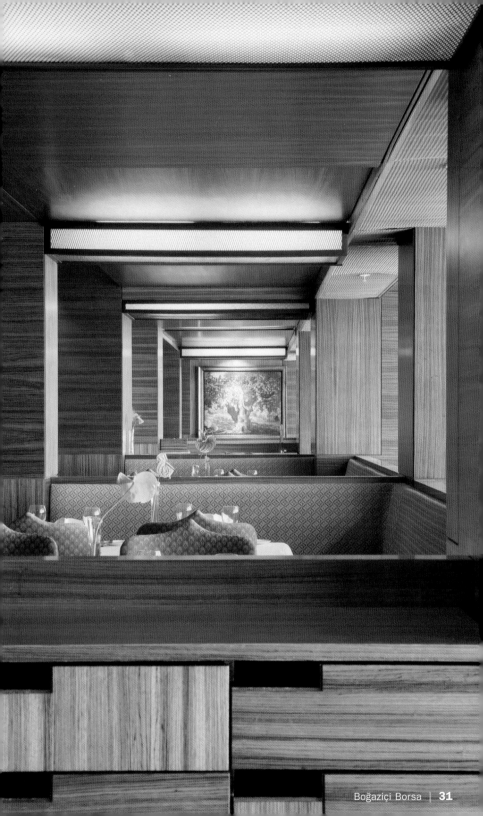

Artichokes with Olive Oil

Artischocken mit Olivenöl
Artichauts à l'huile d'olive
Alcachofas con aceite de oliva
Carciofi con olio d'oliva

4 artichokes
8 pearl onions, peeled
8 carrots, cut in oval shape
8 tbsp peas (convenience product)
4 tbsp olive oil
Juice of 1 lemon
300 ml water
Salt, pepper
Parsley for decoration

Clean the artichokes; leave the stem and sauté immediately with the pearl onions and carrots in olive oil. Deglaze with lemon juice and water and season. Cook the vegetables until tender, right before serving add the peas and heat up. Season again, if necessary, divide amongst four plates and garnish with parsley.

4 Artischocken
8 Perlzwiebeln, geschält
8 tournierte Karotten
8 EL Erbsen (aus dem Glas)
4 EL Olivenöl
Saft von 1 Zitrone
300 ml Wasser
Salz, Pfeffer
Petersilie zur Dekoration

Die Artischocken putzen, dabei den Stiel stehen lassen und sofort mit den Perlzwiebeln und den Karotten in Olivenöl anschwitzen. Mit Zitronensaft und Wasser ablöschen und würzen. Die Gemüse bissfest garen, kurz vor dem Servieren die Erbsen zugeben und erwärmen. Evtl. noch einmal abschmecken, auf vier Tellern verteilen und mit Petersilie garnieren.

4 artichauts
8 oignons grelots épluchés
8 carottes tournées
8 c. à soupe de petits pois (en bocal)
4 c. à soupe d'huile d'olive
Le jus de 1 citron
300 ml d'eau
Sel, poivre
Persil pour la décoration

Nettoyer les artichauts tout en conservant la queue et les faire revenir tout de suite dans l'huile d'olive avec les oignons grelots et les carottes. Mouiller avec le jus de citron et l'eau et assaisonner. Cuire les légumes al dente, ajouter les petits pois juste avant de servir et réchauffer. Rectifier éventuellement l'assaisonnement, répartir sur quatre assiettes et garnir de persil.

4 alcachofas
8 cebolletas peladas
8 bolas de zanahoria
8 cucharadas de guisantes (de bote)
4 cucharadas de aceite de oliva
Zumo de 1 limón
300 ml de agua
Sal y pimienta
Perejil para decorar

Limpiar las alcachofas dejando los tallos y sofreírlas en aceite de oliva con las cebolletas y las zanahorias. Rociarlas con el zumo de limón y agua y salpimentarlas. Rehogar la verdura al dente, añadir los guisantes un momento antes de servir y calentar de nuevo. En caso necesario volver a aderezar. Distribuir en cuatro platos y decorar con perejil.

4 carciofi
8 cipolline senza buccia
8 carote tornite
8 cucchiai di piselli (in barattolo)
4 cucchiai di olio d'oliva
Il succo di 1 limone
300 ml d'acqua
Sale, pepe
Per la guarnizione: prezzemolo

Pulire i carciofi senza staccarne il gambo e rosolarli subito in olio d'oliva con le cipolline e le carote. Bagnare con acqua e succo di limone e condire. Cuocere al dente le verdure, al momento di servire unire i piselli e riscaldare. Eventualmente, regolare il condimento, disporre su quattro piatti e guarnire con il prezzemolo.

Buz Cafe Bar

Design: Geomim, Mahmut Anlar, N. Sinan Erül
Chef: Önder Baltacı | Owners: Lâl Dedeoğlu, Ender Sanal

Abdi İpekçi Cadessi 42/2 | 34367 Istanbul | Tesvikiye Nişantaşı
Phone: +90 212 291 0066
www.buzbar.com
Opening hours: Mon–Sat 11 am to 2 am, Sun closed
Average price: 20 YTL
Cuisine: Italian, Mediterranean

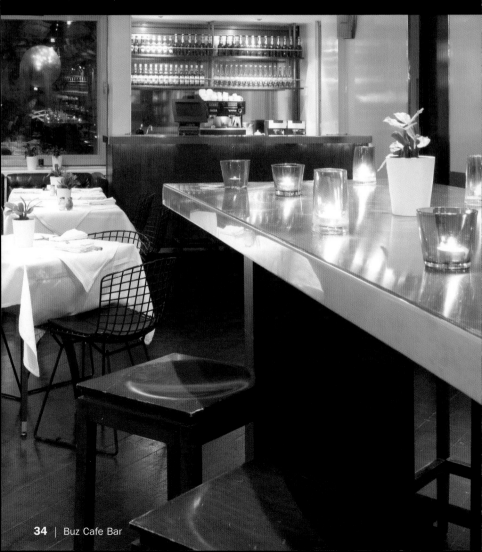

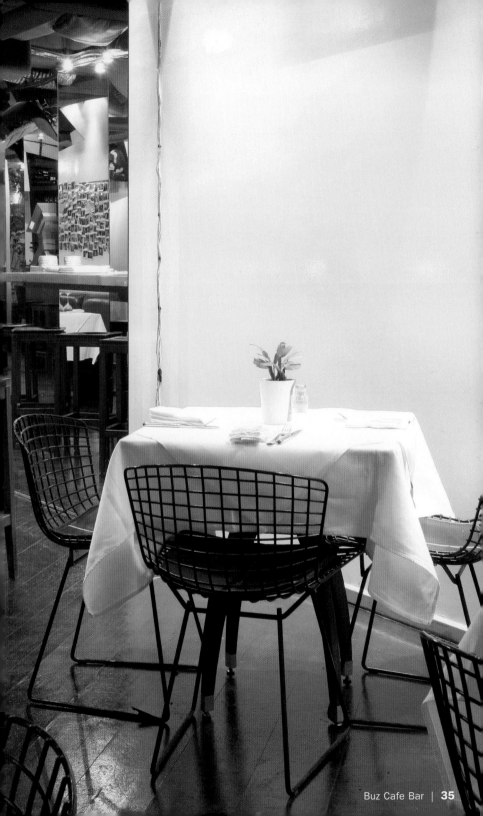

Cezayir

Design: Ofist, Emel Güntaş | Chef: Dilâra Erbay
Owners: Murat Çelikkan, Vildan Erozan, Emel Güntaş,
Melek Taylan, Mehmet Umur

Hayriye Caddesi 16 | 34425 Istanbul | Beyoğlu
Phone: +90 212 245 9980
www.cezayir-istanbul.com
Opening hours: Sun–Thu 9 am to 2 am, Fri–Sat 9 am to 4 am
Average price: 22 YTL
Cuisine: Experimental and traditional Turkish

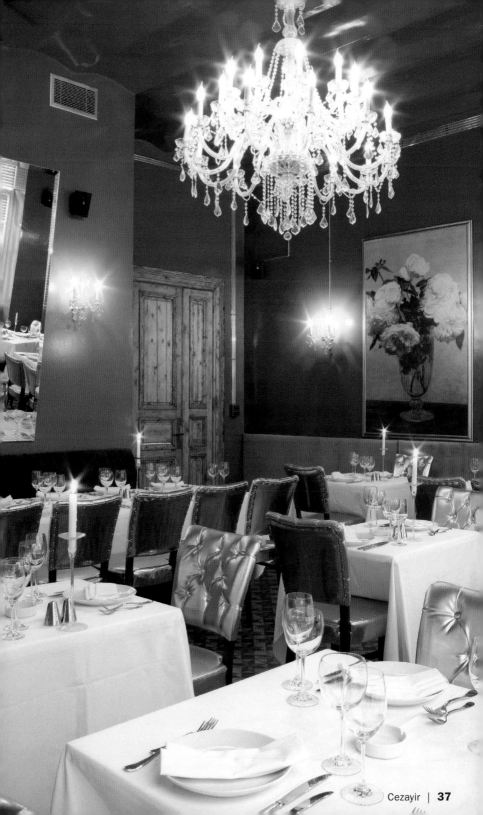

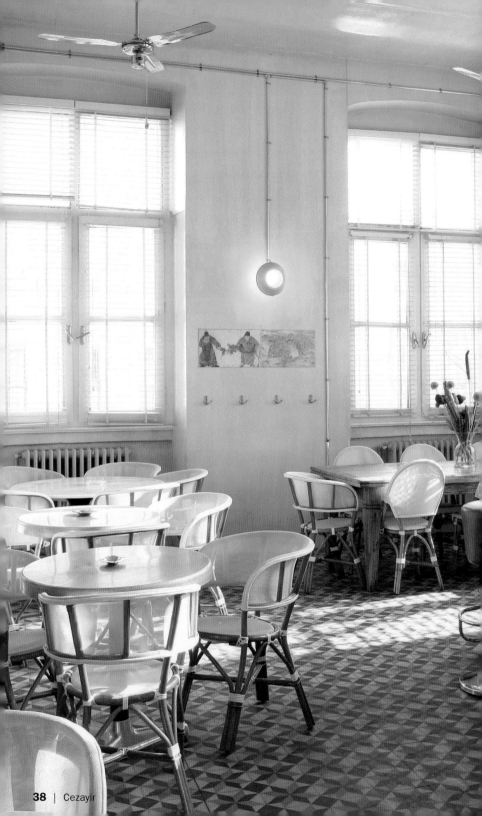

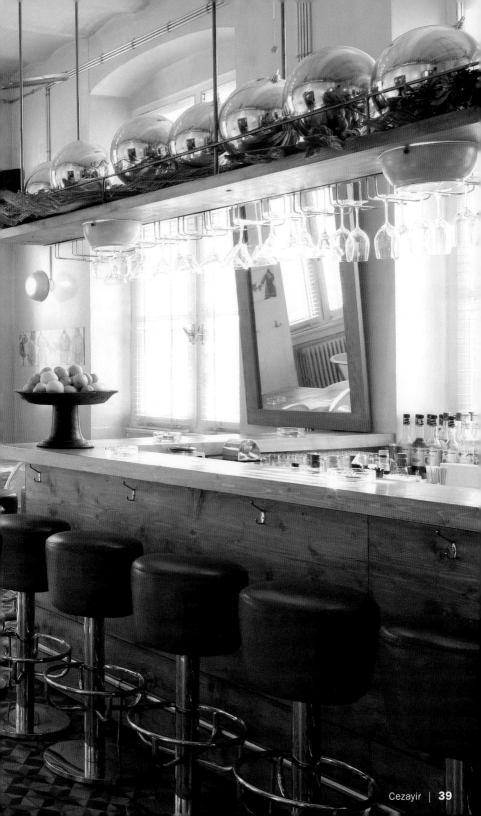

Changa

Design: Gökhan Avcıoğlu | Chef: Changa Team, Peter Gordon
Owners: Savaş Ertunç, Tarık Bayazıt

Sıraselviler Caddesi 87/1 | 34433 Istanbul | Taksim
Phone: +90 212 249 1205
www.changa-istanbul.com
Opening hours: Mon–Sat 6 pm to 1 am, Sun closed
Average price: 27 YTL
Cuisine: Pacific Rim, fusion

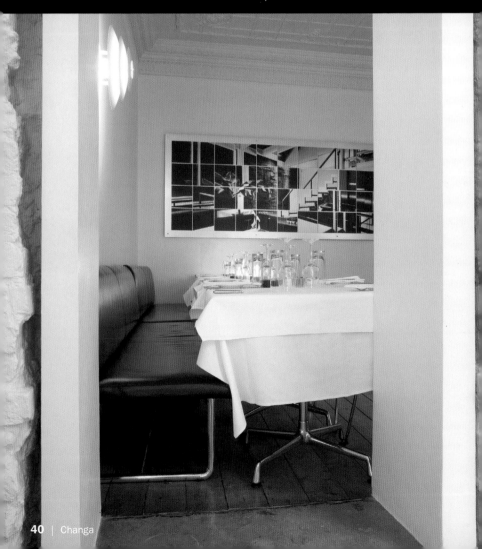

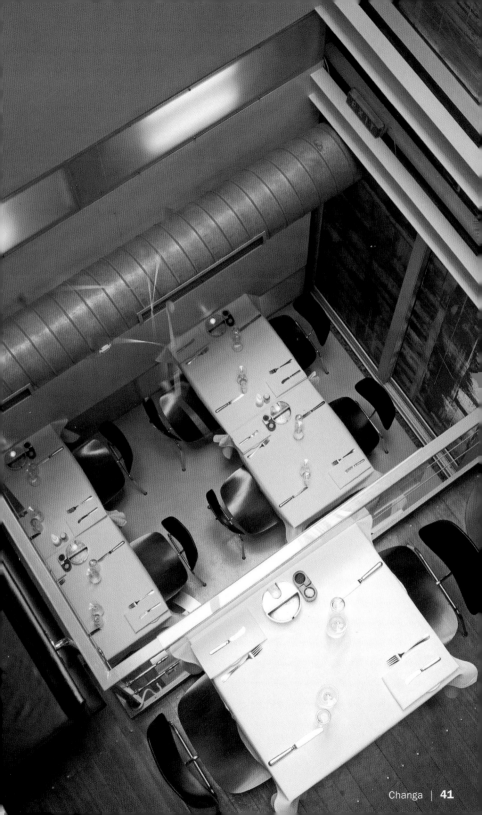

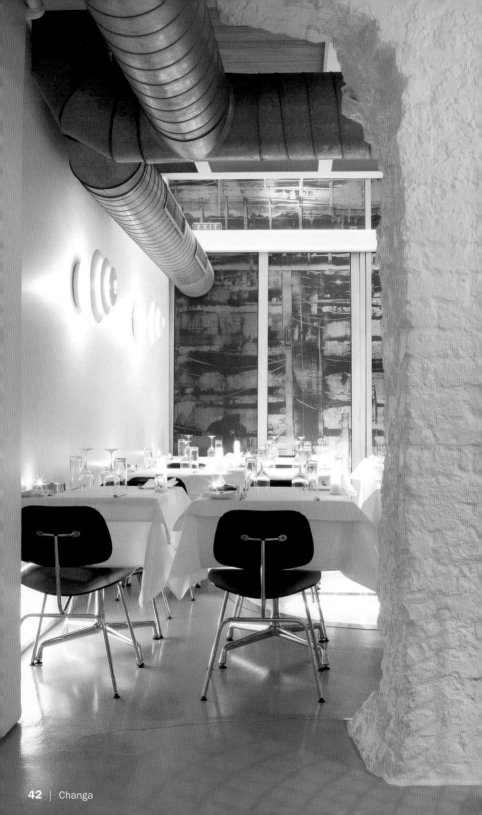

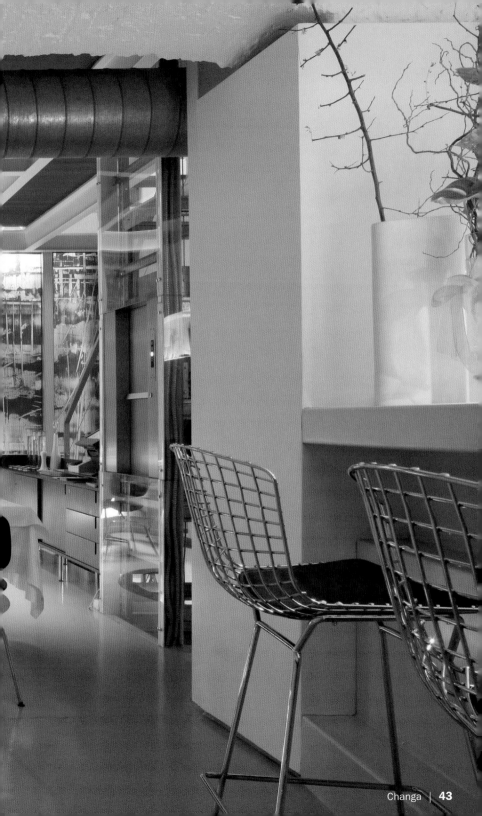

Spice-Pear

in Wine Sauce with Resin Ice Cream and Cotton Candy

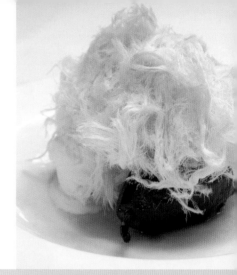

Gewürzbirne in Weinsauce
mit Harz-Eis und Zuckerwatte

Poire aux épices en sauce au vin
avec glace à la résine et barbe à papa

Peras especiadas en salsa de vino con
helado de almáciga y algodón de azúcar

Pera speziata in salsa di vino
con gelato alla resina e zucchero filato

4 pears, peeled
4 dried chilies
1 bay leave
1 twig rosemary
2 pieces star anise
1 stick cinnamon
3 cloves
Juice and zest of 1 lemon
8 ¾ oz sugar
2 tbsp honey
750 ml red wine

Place all ingredients, except the pears, in a large pot, bring to a boil and let simmer gently. Cook the pears in the fond until tender, remove from the fond and reduce the fond to syrup. Pour the syrup through a strainer and place the pears in it. Marinate at least overnight.

4 egg yolks
1 ¾ oz sugar
125 ml cream
125 ml milk
4 tbsp mastic (resin)

Mix egg yolks and sugar, bring the cream with the milk and the resin to a boil, strain and add to the egg yolk-sugar mixture immediately and stir over steam until the mixture thickens. Freeze in an ice maker.

Place one pear on each plate, drizzle syrup over the pears, place one scoop of resin ice cream beside it and cover generously with cotton candy for decoration.

4 Birnen, geschält
4 getrocknete Chilischoten
1 Lorbeerblatt
1 Zweig Rosmarin
2 Stück Sternanis
1 Zimtstange
3 Nelken
Saft und Schale von 1 Zitrone
250 g Zucker
2 EL Honig
750 ml Rotwein

Alle Zutaten, außer den Birnen, in einen großen Topf geben, einmal aufkochen und leise köcheln lassen. Die Birnen in dem Fond bissfest garen, aus dem Fond nehmen und den Fond zu Sirup einkochen. Den Sirup durch ein Sieb gießen und die Birnen darin einlegen. Mindestens über Nacht marinieren lassen.

4 Eigelbe
50 g Zucker
125 ml Sahne
125 ml Milch
4 EL Mastix (Harz)

Eigelbe und Zucker mischen, die Sahne mit der Milch und dem Mastix aufkochen, abseihen, sofort zu der Eigelb-Zuckermischung geben und über Dampf so lange rühren, bis die Mischung andickt. In einer Eismaschine frieren.

Jeweils eine Birne auf vier Tellern verteilen, etwas Sirup über die Birnen träufeln, eine Kugel Harz-Eis daneben setzen und großzügig mit Zuckerwatte als Dekoration bedecken.

4 poires pelées
4 piments séchés
1 feuille de laurier
1 branche de romarin
2 anis étoilés
1 branche de cannelle
3 clous de girofle
Le jus et l'écorce de 1 citron
250 g de sucre
2 c. à soupe de miel
750 ml de vin rouge

Mettre tous les ingrédients, sauf les poires, dans un grand faitout, amener à ébullition et laisser mijoter à feu doux. Faire cuire les poires al dente dans ce fond, les retirer du fond et réduire celui-ci en sirop. Passer ce sirop au chinois et y déposer les poires. Les laisser mariner au moins une nuit.

4 jaunes d'œuf
50 g de sucre
125 ml de crème
125 ml de lait
4 c. à soupe de mastix (résine)

Mélanger les jaunes d'œuf et le sucre, amener la crème à ébullition avec le lait et le mastix, passer au chinois, incorporer immédiatement au mélange œuf-sucre et remuer au bain-marie jusqu'à ce que l'appareil épaississe. Faire prendre dans une sorbetière.

Déposer une poire dans chacune des quatre assiettes, napper les poires de sirop, placer une boule de glace à la résine à côté et recouvrir généreusement de barbe à papa pour la décoration.

4 peras peladas
4 chilis secos
1 hoja de laurel
1 ramita de romero
2 anises estrellados
1 ramita de canela
3 clavos
Zumo y cáscara de 1 limón
250 g de azúcar
2 cucharadas de miel
750 ml de vino tinto

Poner todos los ingredientes en una cazuela grande, llevarlos a ebullición y a continuación cocerlos a fuego lento. Cocer las peras en ese jugo hasta que estén al dente, sacarlas y cocer de nuevo el jugo hasta hacer una jalea. Seguidamente colarla y mezclarla con las peras. Dejarlas en marinado como mínimo una noche.

4 yemas de huevo
50 g de azúcar
125 ml de nata
125 ml de leche
4 cucharadas de almáciga

Mezclar las yemas de huevo y el azúcar, cocer la nata con la leche y la almáciga, colarla, añadirla inmediatamente a la mezcla de yemas y azúcar y remover mientras cuece hasta que la mezcla espese. A continuación meterla en una heladera.

Colocar una pera en cada plato y rociarla con jalea. Añadir una bola de helado de almáciga y cubrirla abundantemente con algodón de azúcar para decorar.

4 pere sbucciate
4 peperoncini secchi
1 foglia di alloro
1 rametto di rosmarino
2 pezzi di anice stellato
1 bacchetta di cannella
3 chiodi di garofano
Il succo e la buccia di 1 limone
250 g di zucchero
2 cucchiai di miele
750 ml di vino rosso

Mettere in una grossa pentola tutti gli ingredienti ad eccezione delle pere, portare a cottura e continuare a cuocere a fuoco lento. Cuocere le pere al dente nel sugo, quindi estrarle e continuare la cottura del sugo finché non sarà diventato sciroppo. Passare lo sciroppo al setaccio e disporvi sopra le pere. Lasciar marinare per almeno una notte.

4 tuorli d'uovo
50 g di zucchero
125 ml di panna
125 ml di latte
4 cucchiai di resina di lentischio

Mescolare i tuorli d'uovo e lo zucchero. Portare a cottura la panna con il latte e il lentischio, passarla al setaccio, incorporarla subito ai tuorli d'uovo ed allo zucchero e cuocere il composto al vapore mescolando finché non si sarà addensato. Congelare in una gelatiera.

Mettere una pera in ogni piatto, pillottarla con un poco di sciroppo, disporvi accanto una pallina di gelato di resina e ricoprire con abbondante zucchero filato per la guarnizione.

Hacı Abdullah

Design: Serdar Anlağan | Chef: Zülfer Gülen
Owners: Mehmet Gülen, Fahri Gündüz, Abdullah Korun,
Rasim Akcan

Sakızağacı Caddesi 17 | 80070 Istanbul | Beyoğlu
Phone: +90 212 293 8561
www.haciabdullah.com.tr
Open hours: Everyday 11 am to 10:30 pm
Average price: 15 YTL
Cuisine: Ottoman

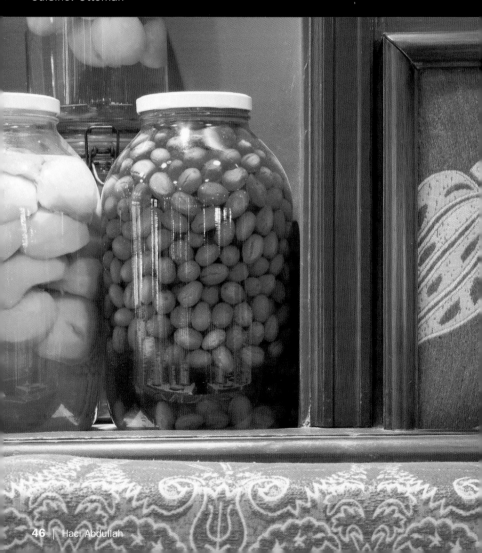

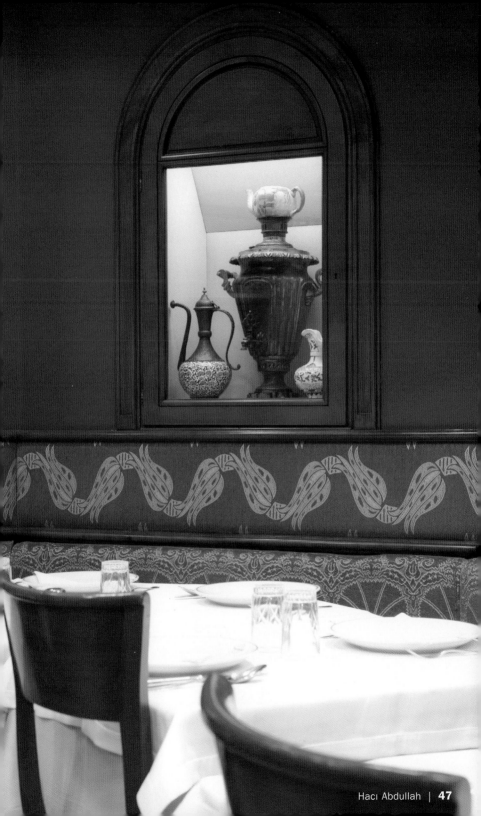

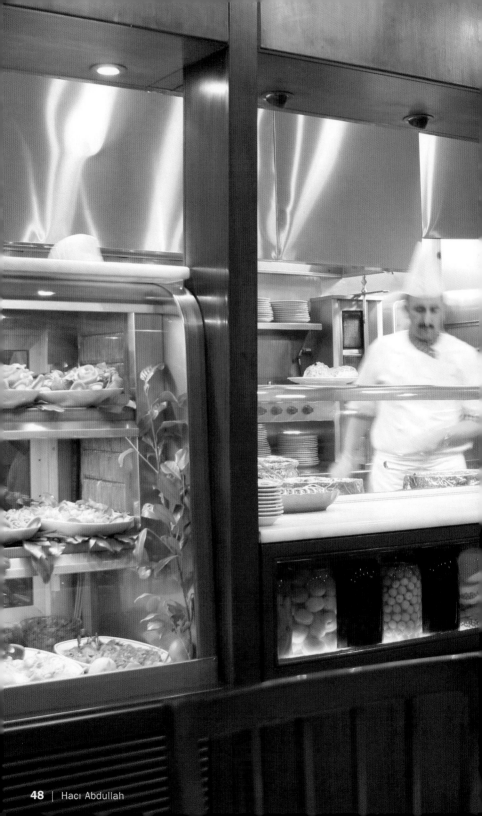

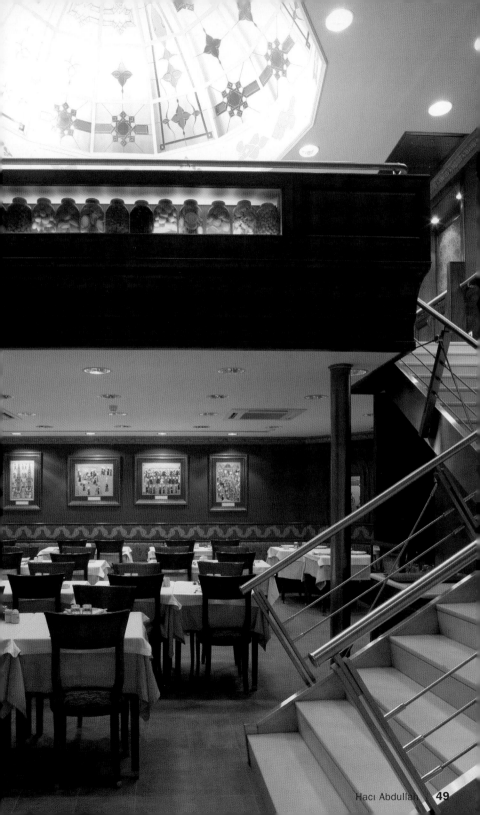

Elbasan Tava

1 lb 9½ oz lamb meat without bones (e.g. shank)
1 l water
4 tbsp butter
Salt, pepper
2 onions, diced
2 twigs thyme
1 tbsp tomato purée
2 cloves of garlic, chopped
7 oz peas, frozen

2 tbsp butter
4 tbsp flour
1 l milk
2 eggs
Salt, pepper
3½ oz grated cheddar cheese
Parsley and tomatoes for decoration

Place the lamb meat with 2 tbsp butter and water in a pot, season and cook the meat until soft. Remove the meat from the brew, let it cool down and cut in large chunks. Heat 2 tbsp butter in a pot, sauté the onions, add meat, thyme, tomato purée and garlic and boil gently for 10 minutes. Season with salt and pepper, stir in the frozen peas and pour into a baking dish. Melt 2 tbsp butter in a small pot, stir in the flour and sauté, deglaze with cold milk and bring to a boil while stirring constantly. Stir in the eggs, season and pour over the meat. Sprinkle with cheese and bake at 360 °F for 15 minutes. Garnish with parsley and fresh tomatoes and serve immediately.

750 g Lammfleisch ohne Knochen (z. B. Keule)
1 l Wasser
4 EL Butter
Salz, Pfeffer
2 Zwiebeln, gewürfelt
2 Zweige Thymian
1 EL Tomatenmark
2 Knoblauchzehen, gehackt
200 g Erbsen, tiefgekühlt

2 EL Butter
4 EL Mehl
1 l Milch
2 Eier
Salz, Pfeffer
100 g geriebener Cheddar-Käse
Petersilienzweige und Tomaten zur Dekoration

Das Lammfleisch mit 2 EL Butter und dem Wasser in einen Topf geben, würzen und das Fleisch gar kochen. Das Fleisch aus dem Sud nehmen, abkühlen lassen und in grobe Stücke zerteilen. 2 EL Butter in einem Topf erhitzen, die Zwiebeln anschwitzen, Fleisch, Thymian, Tomatenmark und Knoblauchzehen zufügen und 10 Minuten köcheln lassen. Mit Salz und Pfeffer würzen, die gefrorenen Erbsen unterrühren und in eine Auflaufform geben. 2 EL Butter in einem kleinen Topf schmelzen lassen, das Mehl unterrühren und anschwitzen, mit kalter Milch ablöschen und unter kräftigem Rühren aufkochen lassen. Die Eier unterrühren, würzen und über das Fleisch geben. Mit Käse bestreuen und bei 180 °C für 15 Minuten überbacken. Mit Petersilienzweigen und frischen Tomaten garnieren und sofort servieren.

750 g de viande d'agneau désossé
(par ex. gigot)
1 l d'eau
4 c. à soupe de beurre
Sel, poivre
2 oignons en dés
2 branches de thym
1 c. à soupe de concentré de tomates
2 gousses d'ail hachées
200 g de petits pois congelés

2 c. à soupe de beurre
4 c. à soupe de farine
1 l de lait
2 œufs
Sel, poivre
100 g de cheddar râpé
Branches de persil et tomates pour la
décoration

Mettre la viande d'agneau avec 2 c. à soupe de beurre et l'eau dans un faitout, assaisonner et faire cuire jusqu'à ce que la viande soit tendre. Retirer la viande du jus de cuisson, laisser refroidir et détailler en gros morceaux. Faire chauffer 2 c. à soupe de beurre dans un faitout, faire revenir les oignons, ajouter la viande, le thym, le concentré de tomates et les gousses d'ail et laisser mijoter 10 minutes. Saler et poivrer, incorporer les petits pois congelés et verser dans un plat à gratin. Faire fondre 2 c. à soupe de beurre dans une petite casserole, ajouter la farine et dessécher, mouiller avec le lait froid et porter à frémissement en remuant vigoureusement. Incorporer les œufs, assaisonner et verser sur la viande. Parsemer de fromage râpé et faire gratiner à 180 °C pendant 15 minutes. Garnir de branches de persil et de tomates fraîches et servir de suite.

750 g de carne de cordero sin hueso
(p.ej. pierna)
1 l de agua
4 cucharadas de mantequilla
Sal y pimienta
2 cebollas picadas
2 ramitas de tomillo
1 cucharada de concentrado de tomate
2 dientes de ajo picados
200 g de guisantes congelados

2 cucharadas de mantequilla
4 cucharadas de harina
1 l de leche
2 huevos
Sal y pimienta
100 g de queso rallado Cheddar
Unas ramitas de perejil y tomates para decorar

Poner en una cazuela el cordero con 2 cucharadas de mantequilla y agua. Salpimentar y guisar la carne hasta que esté tierna. A continuación sacarla del jugo, dejarla enfriar y cortarla en trozos grandes. Calentar 2 cucharadas de mantequilla en una cazuela, sofreír las cebollas, añadirles la carne, el tomillo, el concentrado de tomate, y los dientes de ajo y cocer durante 10 minutos. Salpimentar, añadir los guisantes congelados y poner en una fuente de horno. Derretir 2 cucharadas de mantequilla en un cazo, mezclarlas con la harina, rociar con leche fría y cocer sin dejar de remover. Añadirle los huevos, salpimentar y extender la mezcla sobre la carne. Espolvorear el queso por la superficie y gratinar en el horno a 180 °C durante 15 minutos. Decorar con las ramitas de perejil y los tomates y servir al instante.

750 g di carne d'agnello priva d'ossi
(ad esempio cosciotto)
1 l d'acqua
4 cucchiai di burro
Sale, pepe
2 cipolle tagliate a dadini
2 rametti di timo
1 cucchiaio di concentrato di pomodoro
2 spicchi d'aglio tritati
200 g di piselli surgelati

2 cucchiai di burro
4 cucchiai di farina
1 l di latte
2 uova
Sale, pepe
100 g di formaggio cheddar grattugiato
Per la guarnizione: ciuffi di prezzemolo
e pomodori

Mettere in una pentola la carne d'agnello con l'acqua e 2 cucchiai di burro, condirla e cuocerla. Estrarre la carne dal sugo, lasciarla raffreddare e tagliarla a grossi pezzi. Riscaldare in una pentola 2 cucchiai di burro, rosolarvi le cipolle, unire la carne, il timo, il concentrato di pomodoro e gli spicchi d'aglio e lasciar cuocere a fuoco lento per 10 minuti. Salare, pepare, aggiungere i piselli surgelati e disporre il tutto in una teglia. Sciogliere in un pentolino 2 cucchiai di burro, incorporare la farina, rosolarla, bagnarla con il latte freddo e portarla a cottura mescolando energicamente. Incorporare le uova, condire e versare il tutto sulla carne. Cospargere di formaggio e gratinare in forno a 180 °C per 15 minuti. Guarnire con ciuffi di prezzemolo e pomodori freschi. Servire subito.

Istanbul Modern Café

Design: Tabanlıoğlu Mimarlık | Chef & Owner: Umut Özkanca

Meclis-i Mebusan Caddesi Antrepo 4 | 34425 Istanbul | Karaköy
Phone: +90 212 292 2612
www.istanbulmodern.org
Opening hours: Everyday 10 am to midnight
Average price: Lunch 35 YTL, dinner 60 YTL
Cuisine: Turkish, International
Special features: In the same building as the Istanbul Modern Art Museum

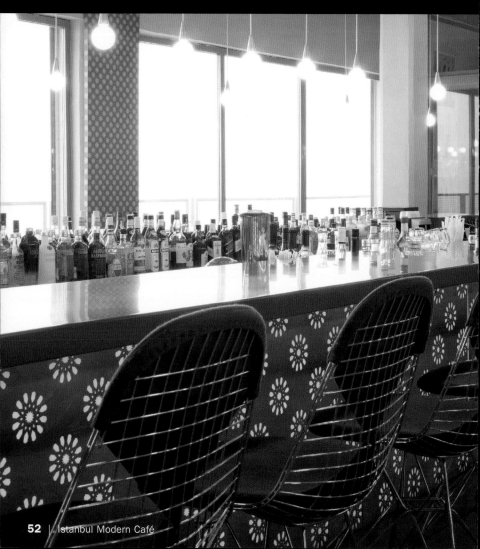

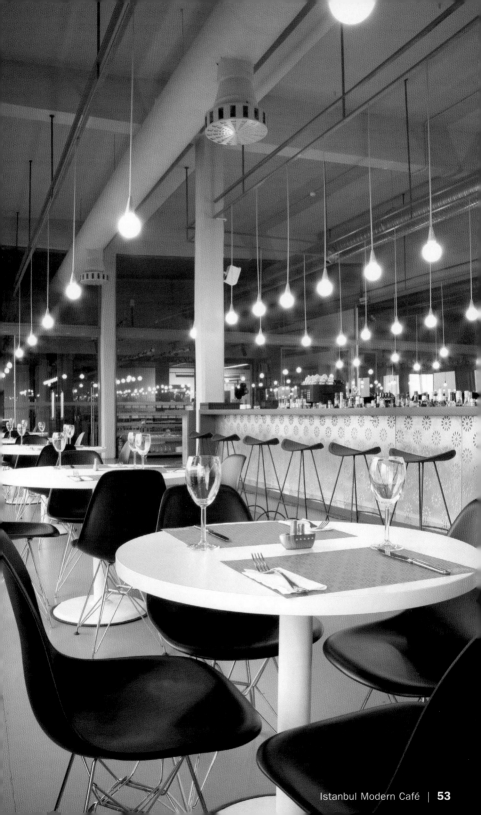

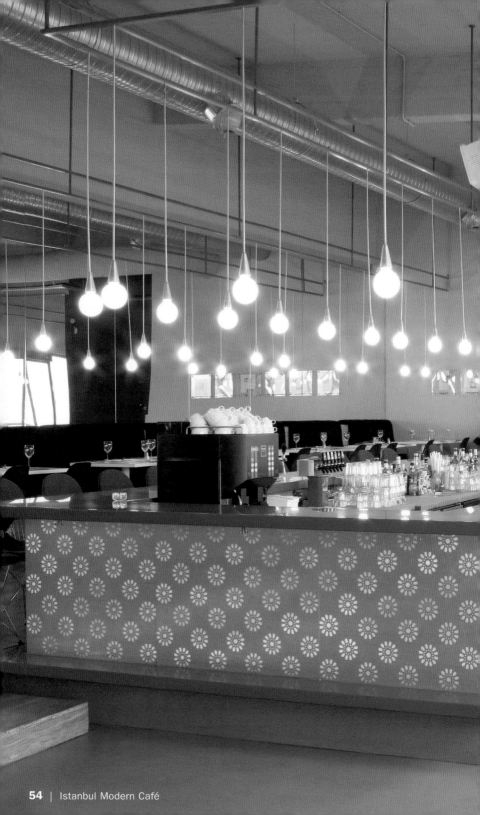

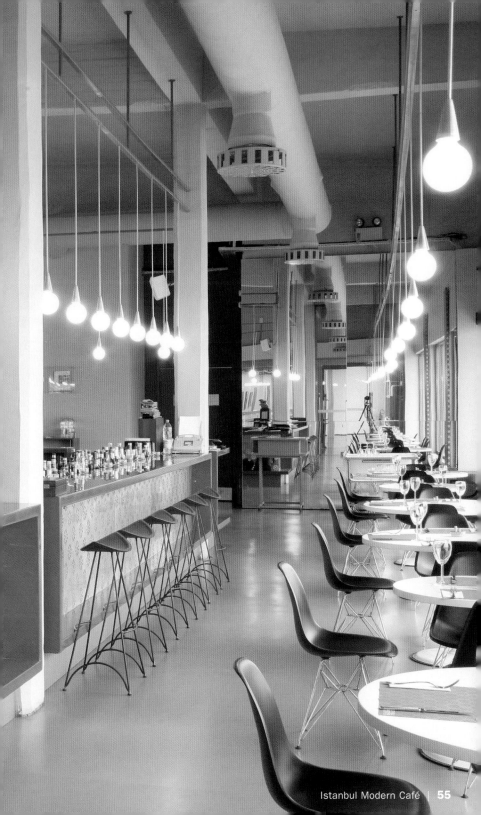

Lakerda

with Arugula and Tarama

Lakerda mit Rucola und Tarama
Lakerda avec rucola et tarama
Lakerda con rúcola y Tarama
Lakerda con rucola e tarama

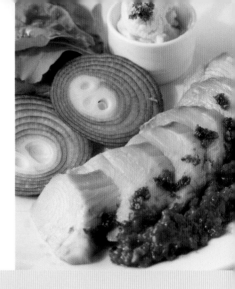

4 ½ oz fish roe
2 slices white bread, soaked
Juice of 1 lemon
100 ml olive oil

For the tarama place the fish roe with the white bread that has been squeezed, the lemon juice and olive oil in a blender and mix until smooth. Season if necessary.

1 lb 4 ½ oz lakerda (marinated bonito, available at the fish store)
2 red onions, in slices
4 oz arugula
7 oz dried tomatoes
6 tbsp olive oil
Salt, pepper

Cut the lakerda in slices, mix the dried tomatoes with the olive oil until smooth and wash the arugula.
Arrange all ingredients on four plates, fill the tarama in small bowls and place on the plates.

125 g Fischrogen
2 Scheiben Weißbrot, eingeweicht
Saft von 1 Zitrone
100 ml Olivenöl

Für die Tarama den Fischrogen mit dem Weißbrot, das zuvor ausgedrückt wurde, dem Zitronensaft und Olivenöl in einen Mixer geben und zu einer glatten Paste mixen. Evtl. abschmecken.

600 g Lakerda (eingelegter Bonito, beim Fischhändler erhältlich)
2 rote Zwiebeln, in Scheiben
120 g Rucola
200 g getrocknete Tomaten
6 EL Olivenöl
Salz, Pfeffer

Lakerda in Scheiben schneiden, die getrockneten Tomaten mit dem Olivenöl pürieren und den Rucola waschen.
Alle Zutaten auf vier Teller arrangieren, die Tarama in kleine Schälchen füllen und auf die Teller stellen.

125 g d'œufs de poisson
2 tranches de pain blanc ramolli
Le jus de 1 citron
100 ml d'huile d'olive

Pour le tarama, mettre dans un mixeur les œufs de poisson avec le pain blanc préalablement écrasé, le jus de citron et l'huile d'olive et mixer pour obtenir une pâte lisse. Assaisonner éventuellement.

600 g de lakerda (bonite en saumure à se procurer chez le poissonnier)
2 oignons rouges en rondelles
120 g de rucola
200 g de tomates séchées
6 c. à soupe d'huile d'olive
Sel, poivre

Couper le lakerda en tranches, réduire les tomates séchées en purée avec l'huile d'olive et laver la salade de rucola.
Répartir tous les ingrédients sur quatre assiettes, remplir de petites jattes de tarama et les placer sur les assiettes.

125 g de huevas de pescado
2 rebanadas de pan blanco mojado
Zumo de 1 limón
100 ml de aceite de oliva

Para preparar la tarama mezclar con la batidora las huevas de pescado, el pan previamente aplastado, el zumo de limón y el aceite de oliva, hasta hacer una pasta. Salpimentar en caso necesario.

600 g de lakerda (bonito escabechado, disponible en pescaderías)
2 cebollas rojas en rodajas
120 g de rúcola
200 g de tomates secos
6 cucharadas de aceite de oliva
Sal y pimienta

Cortar la lakerda en rodajas, hacer un puré con los tomates secos y aceite de oliva y lavar la rúcola.
Repartir todos los ingredientes en cuatro platos, servir la tarama en pequeños cuencos y colocarla en los platos.

125 g di uova di pesce
2 fette di pane bianco ammorbidite
Il succo di 1 limone
100 ml di olio d'oliva

Per la tarama: frullare le uova di pesce con il pane bianco strizzato, il succo di limone e l'olio d'oliva fino ad ottenere un composto liscio. Eventualmente, regolare il condimento.

600 g di lakerda (sarda in conserva, acquistabile in pescheria)
2 cipolle rosse affettate
120 g di rucola
200 g di pomodori secchi
6 cucchiai di olio d'oliva
Sale, pepe

Affettare la lakerda, passare al passaverdura i pomodori secchi con l'olio d'oliva e lavare la rucola.
Disporre in quattro piatti tutti gli ingredienti, versare la tarama in piccole ciotole e metterle sui piatti.

Kordon

Design: Nedret & Mark Butler | Chef: Eftal Çolak

Kuleli Caddesi 51 | 34684 Istanbul | Çengelköy
Phone: +90 216 321 0475
www.kordonbalik.com
Opening hours: Everyday noon to midnight
Average price: 40 YTL
Cuisine: Seafood, Mediterranean
Special features: Restaurant at the hotel Sumahan on the Water

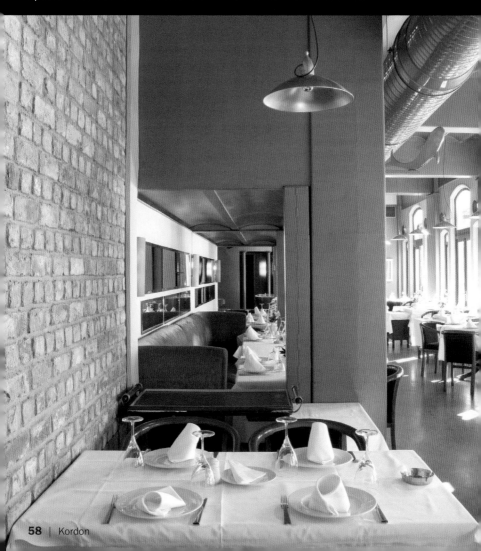

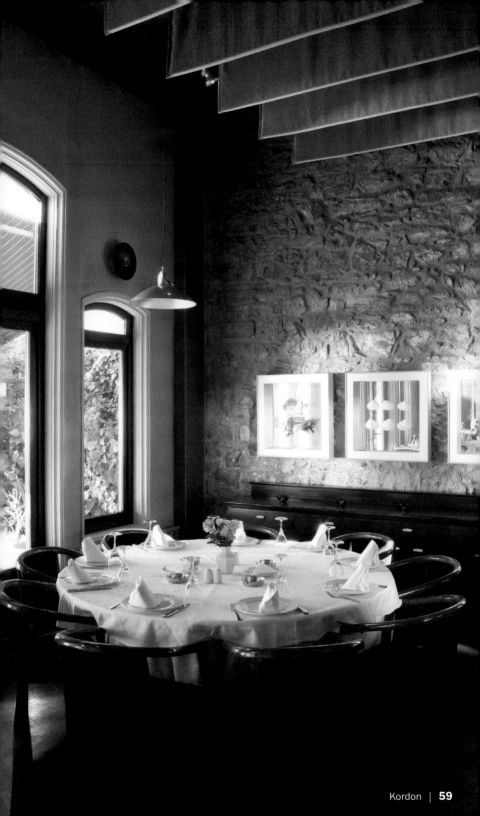

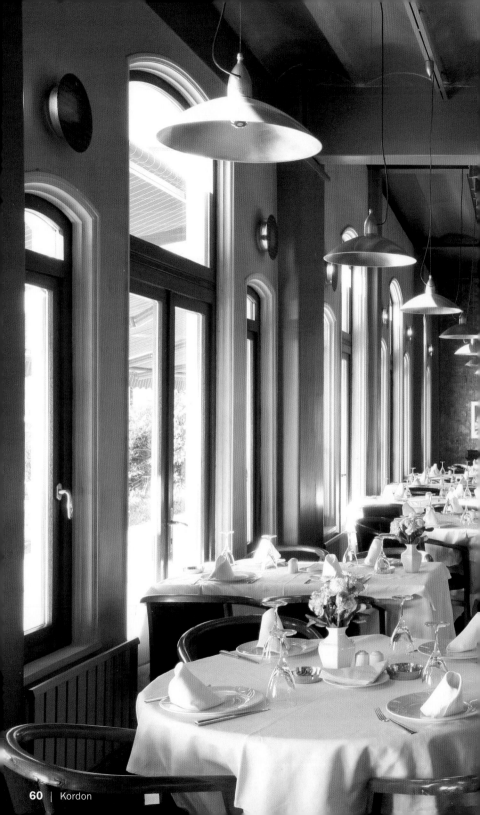

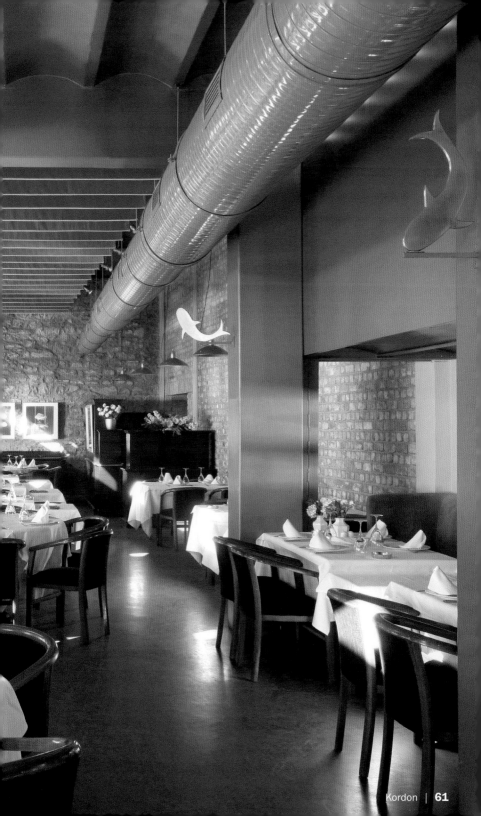

Sea Food Pot

Meeresfrüchtetopf

Fricassée de fruits de mer

Cazuela de mariscos

Pentola di frutti di mare

14 oz lobster meat, raw
4 king prawns, cleaned and raw
8 calamari rings, raw
4 pieces octopus, cooked

7 oz butter
1 tbsp flour
200 ml soy sauce
100 ml water
150 ml tomato juice
10 cloves of garlic, crushed
1 tbsp cream
Salt, pepper

Tomato wedges and green chilies
for decoration

Bake the raw sea food in the oven at 480 °F for approx. 25 minutes, until they turn pink. Remove from the oven and pile in a baking dish with the octopus pieces to four stacks. Melt the butter in a pot, stir in the flour until it turns brown, deglaze with soy sauce, water and tomato juice, while stirring vigorously and bring to a boil. Add the garlic and cream, season and pour over the sea food stacks. Arrange the tomato wedges and chilies around the stacks and bake the baking dish at 390 °F until the sauce comes to a boil. Serve immediately.

400 g Hummerfleisch, roh
4 Riesengarnelen, geputzt und roh
8 Tintenfischringe, roh
4 Stücke Oktopus, gekocht

200 g Butter
1 EL Mehl
200 ml Sojasauce
100 ml Wasser
150 ml Tomatensaft
10 Knoblauchzehen, zerdrückt
1 EL Sahne
Salz, Pfeffer

Tomatenachtel und grüne Chilis
zur Dekoration

Die rohen Meeresfrüchte im Ofen bei 250 °C ca. 25 Minuten backen, bis sie rosa werden. Aus dem Ofen nehmen und in einer Auflaufform mit den Oktopusteilen zu vier Stapeln auf-türmen. Die Butter in einem Topf schmelzen lassen, das Mehl unterrühren und etwas Farbe nehmen lassen, mit Sojasauce, Wasser und Tomatensaft ablöschen, dabei kräftig rühren und zum Kochen bringen. Die Knoblauchzehen und die Sahne zugeben, abschmecken und über die Meeresfrüchtestapel gießen. Tomatenachtel und Chilis um die Stapel legen und die Auflaufform bei 200 °C so lange backen, bis die Sauce anfängt zu kochen. Sofort servieren.

400 g de chair de homard cru
4 gambas nettoyées et crues
8 rondelles de calamar cru
4 morceaux de poulpe cuit

200 g de beurre
1 c. à soupe de farine
200 ml de sauce de soja
100 ml d'eau
150 ml de jus de tomate
10 gousses d'ail écrasées
1 c. à soupe de crème
Sel, poivre

Demi-quarts de tomate et piments verts
pour la décoration

Faire cuire les fruits de mer crus, au four à 250 °C pendant env. 25 minutes jusqu'à ce qu'ils rosissent. Les retirer du four et en confectionner quatre piles avec les morceaux de pulpe à déposer dans un moule à gratin. Faire fondre le beurre dans une casserole, ajouter la farine et laisser dorer légèrement, mouiller avec la sauce de soja, l'eau et le jus de tomate, mélanger vigoureusement et porter à ébullition. Incorporer les gousses d'ail et la crème, assaisonner et verser sur les piles de fruits de mer. Disposer les demi-quarts de tomate et les piments autour des piles et faire cuire le moule à gratin à 200 °C jusqu'à ce que la sauce frémisse. Servir de suite.

400 g de carne de bogavante cruda
4 gambones crudos y limpios
8 anillos de calamar crudos
4 trozos de pulpo cocido

200 g de mantequilla
1 cucharada de harina
200 ml de salsa de soja
100 ml de agua
150 ml de zumo de tomate
10 dientes de ajo aplastados
1 cucharada de nata
Sal y pimienta

Tomates troceados en ocho trozos
y chiles verdes para decorar

Cocinar los mariscos en el horno durante 25 minutos a 250 °C aprox. hasta que queden rosados. Sacarlos del horno y colocarlos en cuatro torretas sobre una fuente, junto con los trozos de pulpo. Derretir la mantequilla en una cazuela, añadirle la harina y tostarla ligeramente y a continuación rociarla con la salsa de soja, agua y el zumo de tomate, removiendo constantemente hasta que llegue a cocer. Agregar los dientes de ajo y la nata, salpimentar y rociar la mezcla sobre las torretas de marisco. Colocar los chiles y los trozos de tomate rodeándolas y cocinarlas en el horno a 200 °C hasta que la salsa hierva. Servir directamente.

400 g di polpa d'astice cruda
4 gamberoni crudi puliti
8 anelli di calamari crudi
4 pezzi di polipo bolliti

200 g di burro
1 cucchiaio di farina
200 ml di salsa di soia
100 ml d'acqua
150 ml di succo di pomodoro
10 spicchi d'aglio schiacciati
1 cucchiaio di panna
Sale, pepe

Per la guarnizione: spicchi di pomodoro
e peperoncini verdi

Cuocere in forno i frutti di mare crudi a 250 °C per circa 25 minuti, finché siano di colore rosato. Estrarli dal forno e disporli a strati in una teglia con i pezzi di polipo, formando quattro colonne. Far sciogliere il burro in una pentola, incorporare la farina, rosolarla un poco, bagnare con la salsa di soia, l'acqua ed il succo di pomodoro, mescolare energicamente e portare a cottura. Unire gli spicchi d'aglio e la panna, assaggiare, regolare il condimento e versare sui frutti di mare. Disporvi attorno gli spicchi di pomodoro ed i peperoncini e cuocere in forno a 200 °C finché la salsa inizia a bollire. Servire subito.

Köşebaşı Beylikdüzü

Design: Önder Kul | Chef: Serkan Çelikbaş | Owners: Ali Akkaş, Nedim Aşkın, Bülent Temuroğlu, Mehmet Yeşilyurt

Kaya Ramada Plaza Yanı, E-5 Otoyolu Tüyap Yanı | 34900 Istanbul | Büyükçekmece
Phone: +90 212 886 6699
www.kosebasi.com.tr
Opening hours: Everyday noon to midnight
Average price: 14 YTL
Cuisine: South Anatolian
Special features: Also in Levent, Fenerbahçe, Nişantaşı, Beylikdüzü & Reina

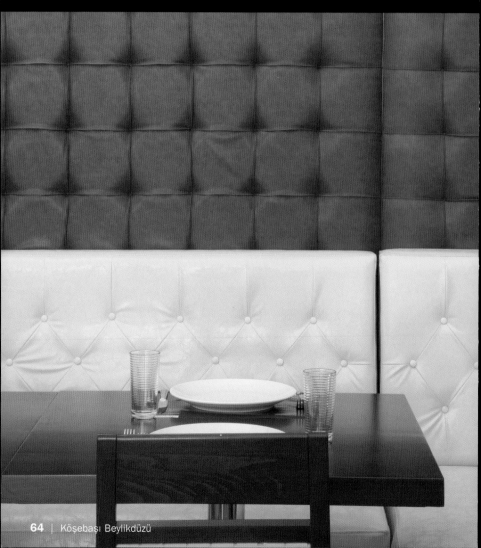

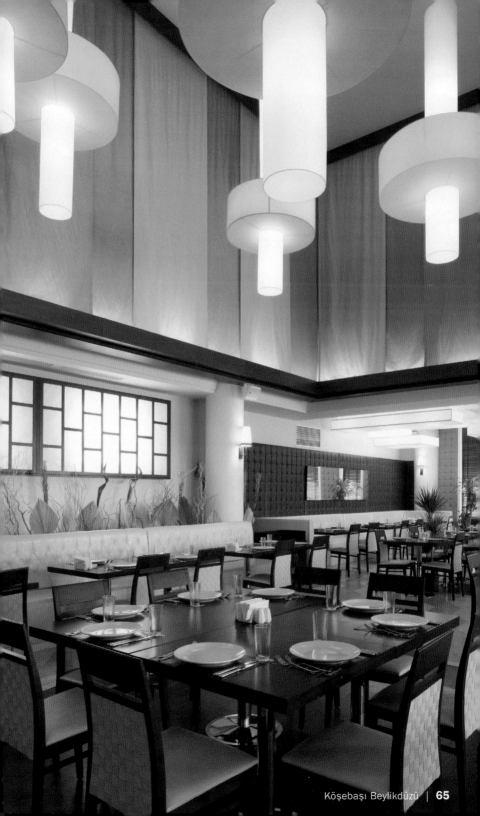

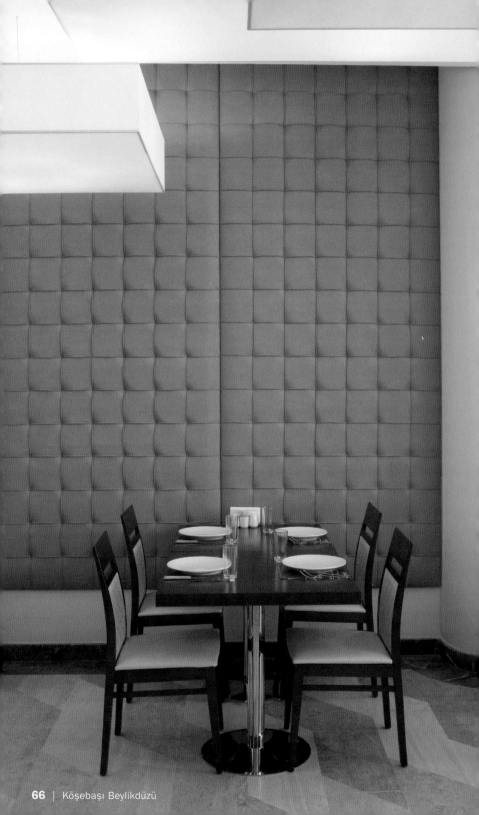

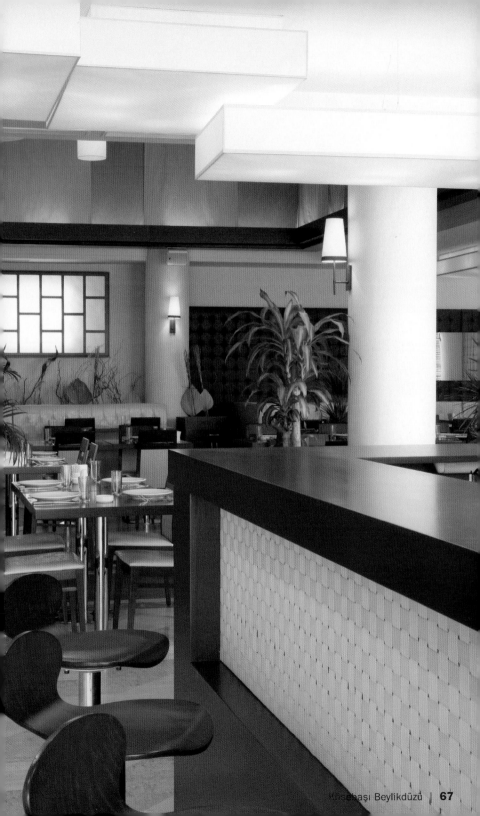

Leyla

Design: Ofist, Emel Güntaş, Akarsu Sokak, Cihangir
Owners: Deniz Türkali, İbrahim Soğukdağ, Tangül Özer

Akarsu Caddesi 46 | 34433 Istanbul | Cihangir
Phone: +90 212 244 5350
leyla@leyla2004.com
Opening hours: Everyday 8 am to 4 am
Average price: 17 YTL
Cuisine: Café, bar
Special features: DJ everyday except on Sundays

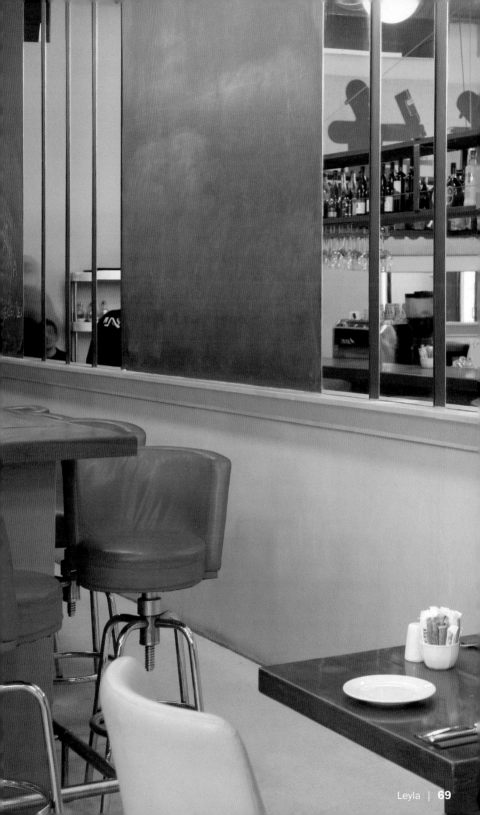

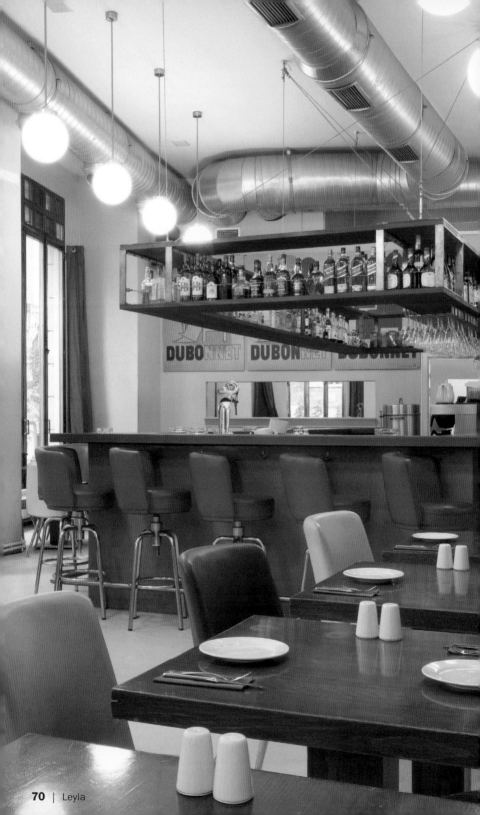

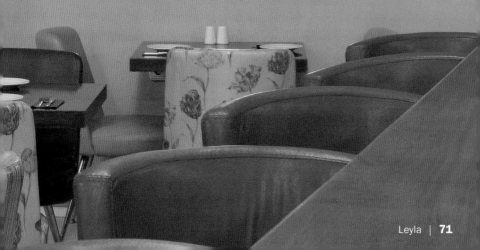

Loft

Design: Nazlı Gönensay | Chef: Umut Özkanca
Owner: Borsa Restaurant Group

Lütfi Kırdar Convention & Exhibition Center, Rumeli Building
80230 Istanbul | Harbiye
Phone: +90 212 219 6384
www.loftrestbar.com
Opening hours: Mon–Sat noon to midnight, Sun 6 pm to midnight
Average price: 70 YTL
Cuisine: International

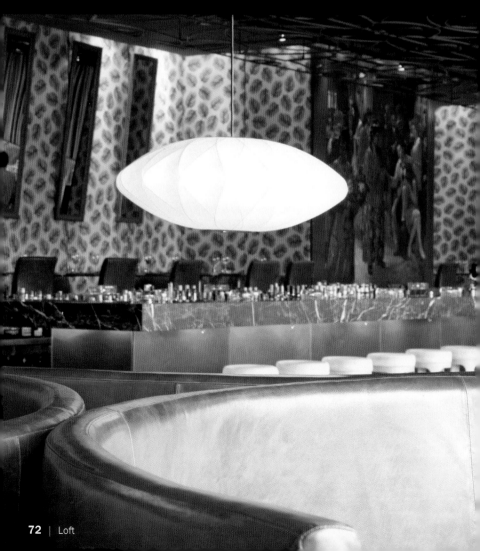

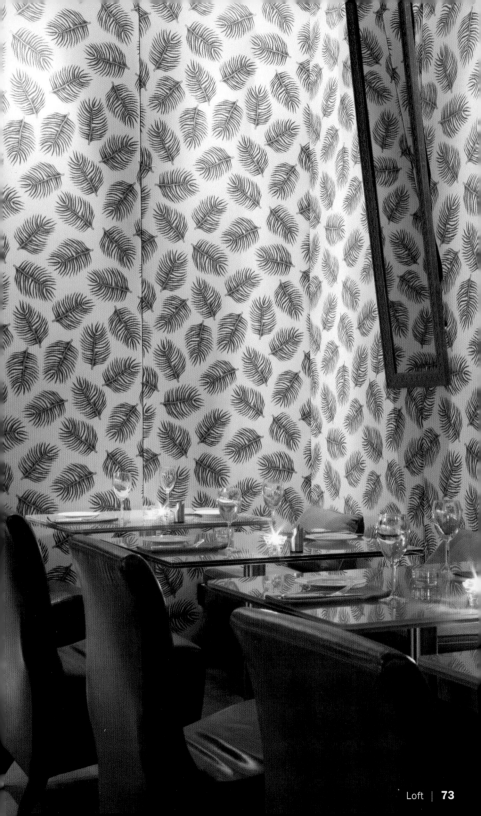

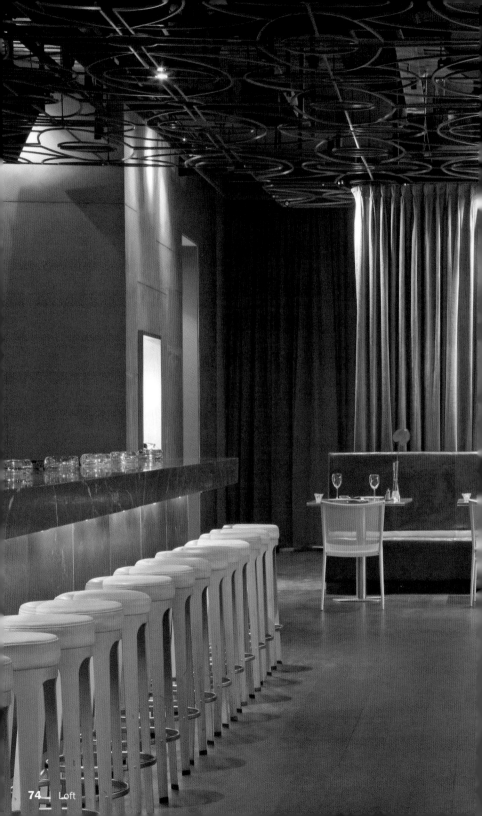

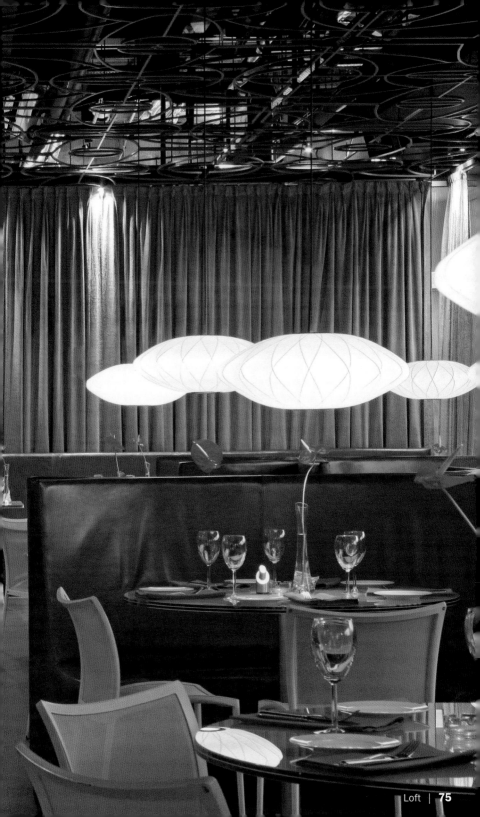

Lokanta

Design: Ofist, Yasemin Arpaç, Sabahattin Emir
Chef & Owner: Mehmet Gürs

Meşrutiyet Caddesi 149/1 | 34430 Istanbul | Tepebaşı
Phone: +90 212 245 6070
www.istanbulyi.com
Opening hours: Mon–Sat from noon on, Sun closed, holidays Jun to Oct
Average price: 25 YTL
Cuisine: International with Turkish accent
Special features: Daily DJ performance

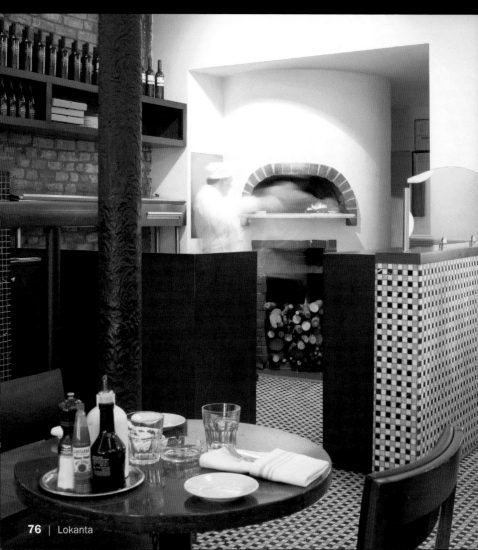

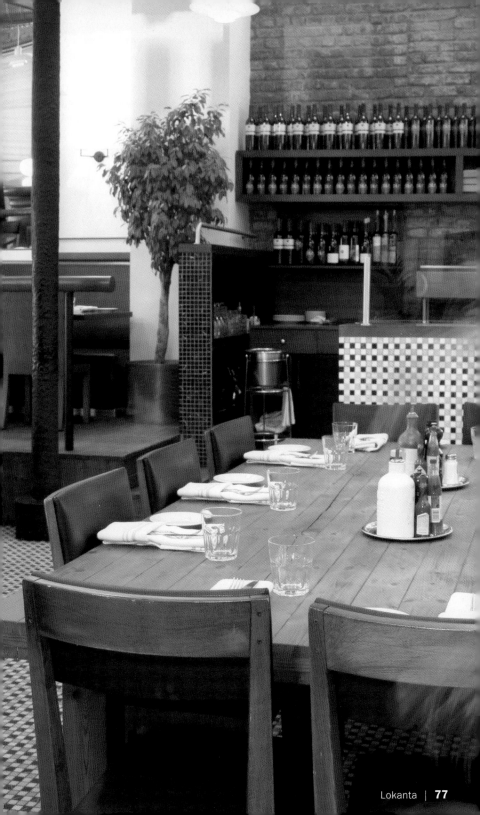

Lucca

Designer: Uras + Dilekçi Architects | Chef: Kerem Delibalta,
Luigi Frecilla | Owner: Cem Mirap

Cevdet Paşa Caddesi 51/B | 34342 Istanbul | Bebek
Phone: +90 212 257 1255
www.luccastyle.com
Opening hours: Everyday 10 am to 2 am
Average price: 22 YTL
Cuisine: American, Mediterranean

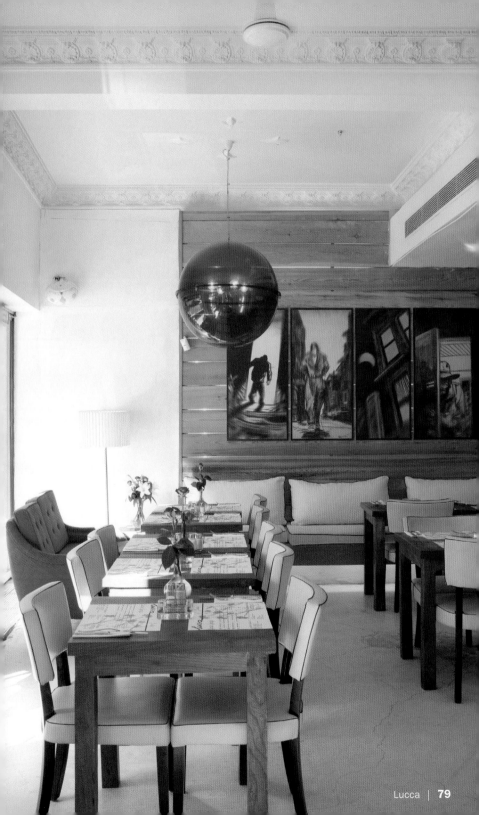

Sea Bass

in Lemon Sauce with Mint Rice

Seebarsch in Zitronensauce an Minzreis

Bar à la sauce citron et riz à la menthe

Lubina en salsa de limón y arroz a la menta

Branzino in salsa al limone con riso alla menta

4 sea bass fillets, without fish bones
Salt, pepper
4 tbsp olive oil
6 tbsp white wine
Juice of 2 lemons
6 tbsp cream

5½ oz rice
Salt
400 ml water
1 bunch mint

Flowers for decoration

Cook the rice and set aside. Season the fish fillets, sear in a pan on both sides in olive oil, remove from the pan and deglaze the drippings with white wine. Add lemon juice and cream, place the sea bass in the sauce, bring to a boil and season. Chop the mint and fold under the rice. Divide rice and fish amongst four plates, drizzle with sauce and garnish with flowers.

4 Seebarschfilets ohne Gräten
Salz, Pfeffer
4 EL Olivenöl
6 EL Weißwein
Saft von 2 Zitronen
6 EL Sahne

160 g Reis
Salz
400 ml Wasser
1 Bund Minze

Blüten zur Dekoration

Den Reis garen und beiseite stellen. Die Fischfilets würzen, von beiden Seiten in Olivenöl in einer Pfanne scharf anbraten, herausnehmen, und den Bratensatz mit Weißwein ablöschen. Zitronensaft und Sahne zufügen, den Seebarsch in die Sauce geben, nochmals aufkochen lassen und würzen. Die Minze klein hacken und unter den Reis geben. Reis und Fisch auf vier Tellern verteilen, mit Sauce begießen und mit Blüten garnieren.

4 filets de bar sans arêtes
Sel, poivre
4 c. à soupe d'huile d'olive
6 c. à soupe de vin blanc
Le jus de 2 citrons
6 c. à soupe de crème

160 g de riz
Sel
400 ml d'eau
1 bouquet de menthe

Fleurs pour la décoration

Faire cuire le riz et réserver. Assaisonner les filets de poisson, les faire dorer dans une poêle, à feu vif, des deux côtés dans l'huile d'olive, les retirer de la poêle et déglacer le fond au vin blanc. Ajouter le jus des citrons et la crème, mettre les filets dans la sauce, donner un tour de bouillon et assaisonner. Hacher fin la menthe et la mélanger au riz. Répartir le riz et le poisson sur quatre assiettes, arroser de sauce et garnir de fleurs.

4 filetes de lubina sin espinas
Sal y pimienta
4 cucharadas de aceite de oliva
6 cucharadas de vino blanco
Zumo de 2 limones
6 cucharadas de nata

160 g de arroz
Sal
400 ml de agua
1 ramillete de menta

Flores para decorar

Cocinar el arroz y dejarlo aparte. Salpimentar los filetes de pescado, freírlos por ambas caras en una sartén con aceite de oliva; sacarlos y rociar con vino blanco el jugo resultante del frito. Añadirle nata y zumo de limón y a continuación agregar los filetes de pescado. Rehogar de nuevo y salpimentar. Picar la menta y mezclarla con el arroz. Distribuir el pescado y el arroz en cuatro platos, rociarlos con la salsa y decorarlos con flores.

4 filetti di branzino diliscati
Sale, pepe
4 cucchiai di olio d'oliva
6 cucchiai di vino bianco
Il succo di 2 limoni
6 cucchiai di panna

160 g di riso
Sale
400 ml d'acqua
1 mazzetto di menta

Per la guarnizione: fiori

Cuocere il riso e metterlo da parte. Condire i filetti di pesce, rosolarli in padella a fuoco vivo in olio di oliva da entrambi i lati, estrarli e bagnare il fondo di cottura dell'arrosto con il vino bianco. Unire il succo di limone e la panna, immergere il branzino nella salsa, portare nuovamente a cottura e condire. Triturare la menta ed incorporarla al riso. Ripartire il riso ed il pesce in quattro piatti, versarvi sopra la salsa e guarnire con i fiori.

Mangerie

Design: Elif Yalın | Chef & Owners: Elif Yalın, Durmuş Doğan

Cevdet Paşa Caddesi 69/3 | 34342 Istanbul | Bebek
Phone: +90 212 263 5199
Opening hours: Everyday 8 am to midnight
Average price: 20 YTL
Cuisine: Café, bistro

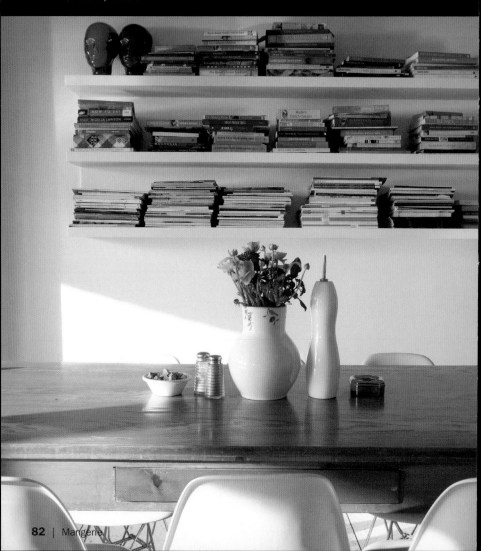

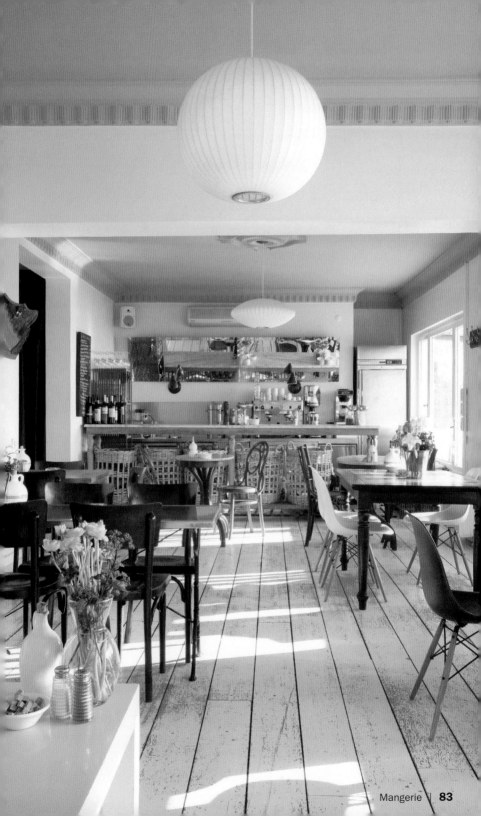

Fish Sandwich

Fischsandwich

Sandwich au poisson

Bocadillo de pescado

Pane con pesce

4 slices marinated eggplant (convenience product)
1 clove of garlic
Olive oil
Salt, pepper
Combine all ingredients in a blender and mix until it resembles a smooth pesto.

4 oz green olives
1 bunch dill, cilantro, parsley and peppermint each
4 anchovies
1 tbsp coarse mustard
1 clove of garlic
Juice of 1 lemon
Olive oil
Mix all ingredients to a smooth paste as well.

1 loaf Turkish corn bread, quartered and halved
4 oz arugula
4 slices grilled, marinated red bell pepper
4 sea bass fillets, 5½ oz each, grilled

Put pesto on one half of the bread, on the other side olive tapenade, divide arugula amongst the sandwiches and place one sea bass fillet and red bell pepper on each sandwich. Fold both halves together and squeeze gently.

4 Scheiben eingelegte Aubergine (aus dem Glas)
1 Knoblauchzehe
Olivenöl
Salz, Pfeffer
Alle Zutaten in einen Mixer geben und zu einem glatten Pesto pürieren.

120 g grüne Oliven
Je 1 Bund Dill, Koriander, Petersilie und Pfefferminze
4 Anchovis
1 EL körniger Senf
1 Knoblauchzehe
Saft von 1 Zitrone
Olivenöl
Alle Zutaten ebenfalls zu einer glatten Paste pürieren.

1 Laib türkisches Maisbrot, geviertelt und halbiert
120 g Rucola
4 Scheiben gegrillte, eingelegte rote Paprika
4 Seebarschfilets, à 160 g, gegrillt

Auf die eine Seite des Brotes Pesto, auf die andere Seite Olivenpaste streichen, Rucola auf allen vier Sandwiches verteilen und je ein Seebarschfilet und eine Paprikascheibe auf das Sandwich legen. Beide Hälften aufeinander legen und leicht zusammendrücken.

4 tranches d'aubergines marinées (en bocal)
1 gousse d'ail
Huile d'olive
Sel, poivre
Mettre tous les ingrédients dans un mixeur et
en faire un pesto lisse.

120 g d'olives vertes
Respectivement 1 bouquet d'aneth, de
coriandre, de persil et de menthe
4 anchois
1 c. à soupe de moutarde en grains
1 gousse d'ail
Le jus de 1 citron
Huile d'olive
Réduire de même tous les ingrédients en une
purée lisse.

1 miche de pain turc au maïs, en quartiers
coupés en deux
120 g de rucola
4 tranches de poivron rouge grillé mariné
4 filets de bar de 160 g, grillés

Tartiner un côté du pain avec le pesto, l'autre
avec la pâte d'olives, répartir la rucola sur les
quatre sandwichs, déposer un filet de bar et
une tranche de poivron dans chaque sandwich.
Fermer le sandwich et presser légèrement.

4 rodajas de berenjenas marinadas (de bote)
1 diente de ajo
Aceite de oliva
Sal y pimienta
Mezclar todos los ingredientes en la batidora
hasta hacer un pesto.

120 g aceitunas verdes
1 ramillete de eneldo, cilantro, perejil y hierba-
buena respectivamente
4 anchoas
1 cucharada de mostaza con grano
1 diente de ajo
Zumo de 1 limón
Aceite de oliva
Hacer igualmente una pasta con todos los
ingredientes.

1 pan de maíz turco abierto y cortado en cuatro
trozos
120 g de rúcola
4 rodajas de pimiento asado marinado
4 filetes de lubina, de unos 160 g, a la plancha

Extender en una cara del pan el pesto y en la
otra la pasta de aceitunas. Repartir la rúcola
en los cuatro bocadillos y poner en cada uno
un filete de lubina y una rodaja de pimiento.
Juntar las dos caras del pan y presionarlas
ligeramente.

4 fette di melanzane sott'olio (in barattolo)
1 spicchio d'aglio
Olio d'oliva
Sale, pepe
Frullare tutti gli ingredienti fino ad ottenere un
pesto liscio.

120 g di olive verdi
1 mazzetto di dragoncello
1 mazzetto di coriandolo
1 mazzetto di prezzemolo
1 mazzetto di menta piperita
4 acciughe
1 cucchiaio di grani di senape
1 spicchio d'aglio
Il succo di 1 limone
Olio d'oliva
Frullare tutti gli ingredienti fino ad ottenere un
composto liscio.

1 forma di pane di mais turco, tagliato in quattro
e quindi dimezzato
120 g di rucola
4 fette di peperoni rossi sott'olio grigliati
4 filetti di branzino alla griglia, di 160 g ciascuno

Su un lato del pane spalmare il pesto, sull'altro
la pasta di olive. Ripartire la rucola sui quattro
sandwich e disporre su ognuno un filetto di
branzino e una fetta di peperoni. Disporre una
sull'altra le due metà e pressarle leggermente.

Mikla

Design: Geomim, Mahmut Anlar, N. Sinan Erül
Chef & Owner: Mehmet Gürs

The Marmara Pera Hotel, Meşrutiyet Caddesi 167/185 | 34430 Istanbul | Tepebaşı
Phone: +90 212 293 5656
www.istanbulyi.com
Opening hours: Everyday noon to 3:30 pm, 7 pm to 2 am
Average price: 40 YTL
Cuisine: Refined Mediterranean
Special features: View of the main historical peninsula Sultanahmet

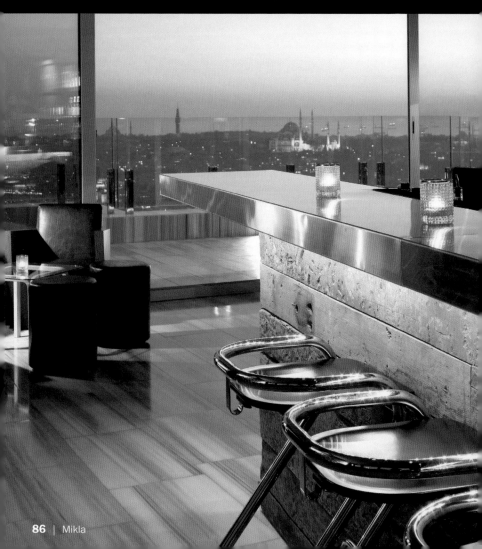

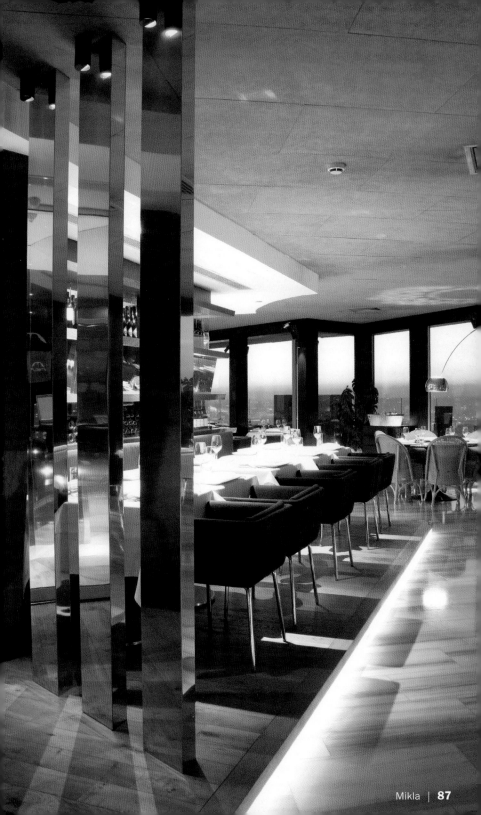

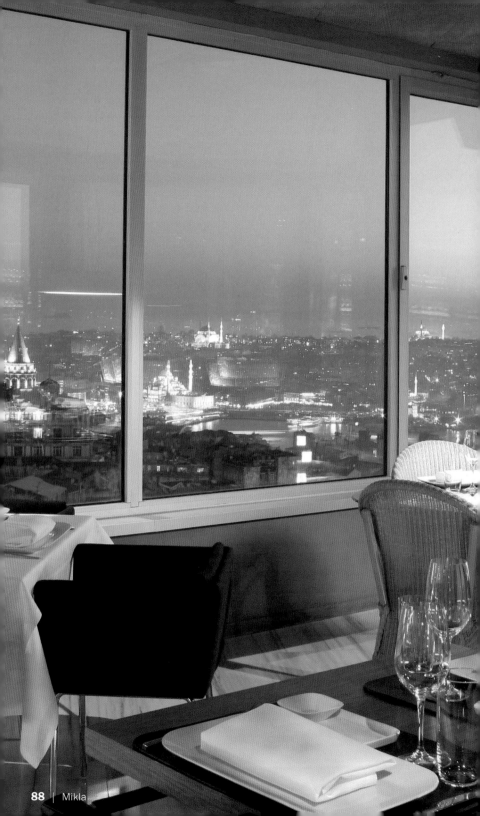

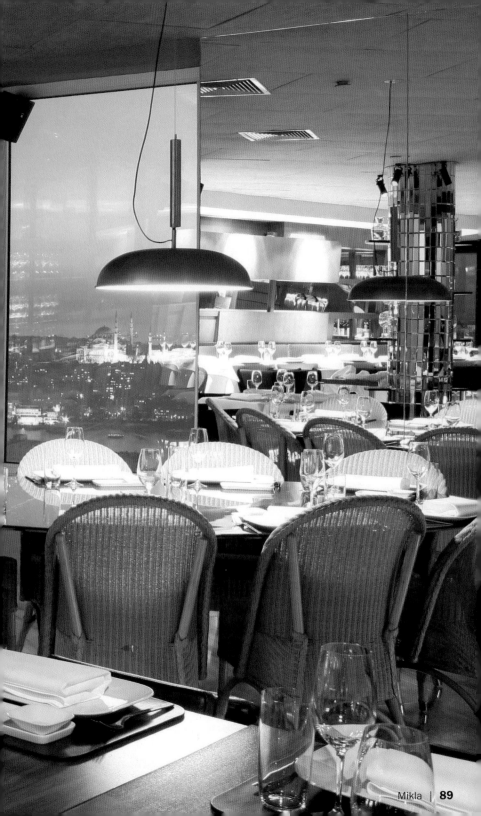

Mirror Suadiye

Design: Toner Mimarlık, Mustafa Toner | Chef: Necati Aylan
Owner: Gürhan Ersin

Suadiye Park, A Blok, Kat 2 | 34740 Istanbul | Suadiye
Phone: +90 216 464 2711
www.mirrorbistro.com
Opening hours: Everyday 11 am to 2 am
Average price: 25 YTL
Cuisine: Italian, world cuisine
Special features: Every night DJ performance, terrace dining during summer

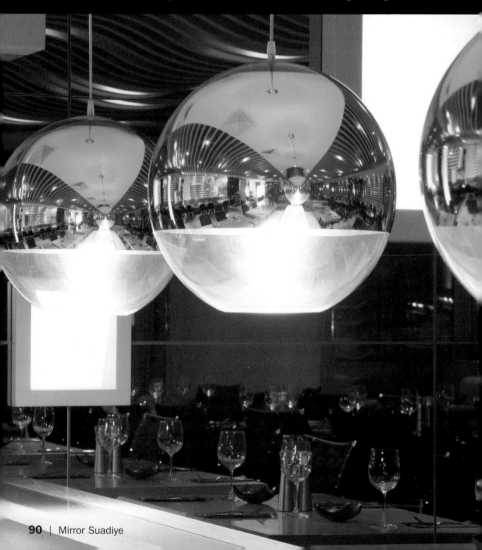

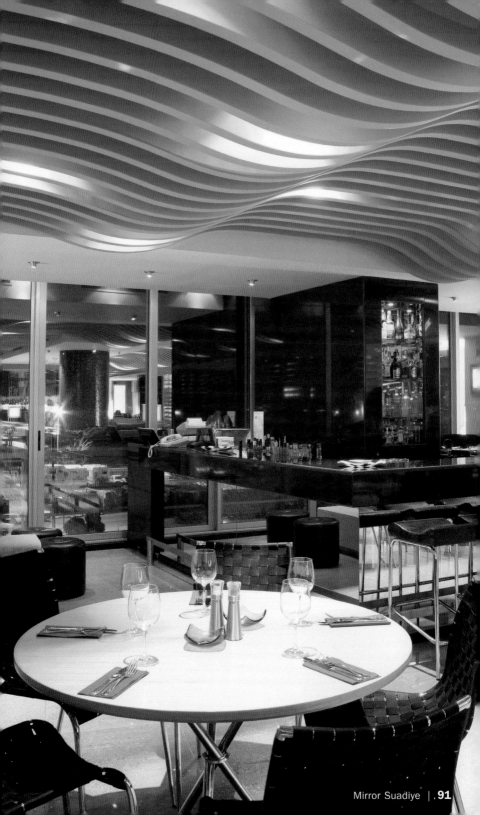

Moda Teras

Design: Autoban, Seyhan Özdemir, Sefer Çağlar
Owners: Ayşe Kolat, Safiye Özüak | Chef: Kadir Soygüzel

Mektep Sokak 7/9 | 34710 Istanbul | Moda
Phone: +90 216 338 7040
www.modateras.com
Opening hours: Sun–Thu 10 am to 1 am, Fri–Sat 10 am to 2 am
Cuisine: Mediterranean, Turkish
Average price: Lunch 30 YTL, dinner 60 YTL
Special features: Every Friday DJ (80's, 90's)

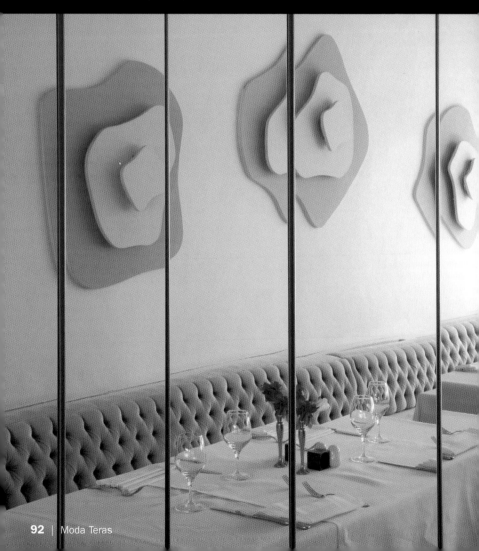

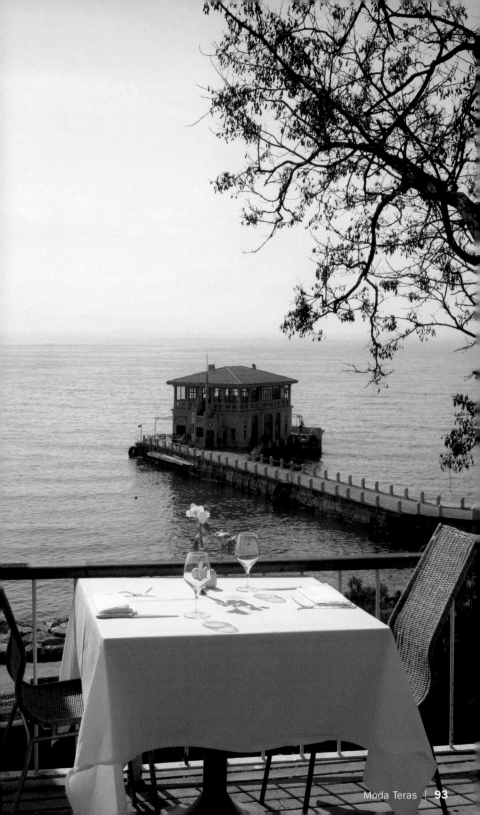

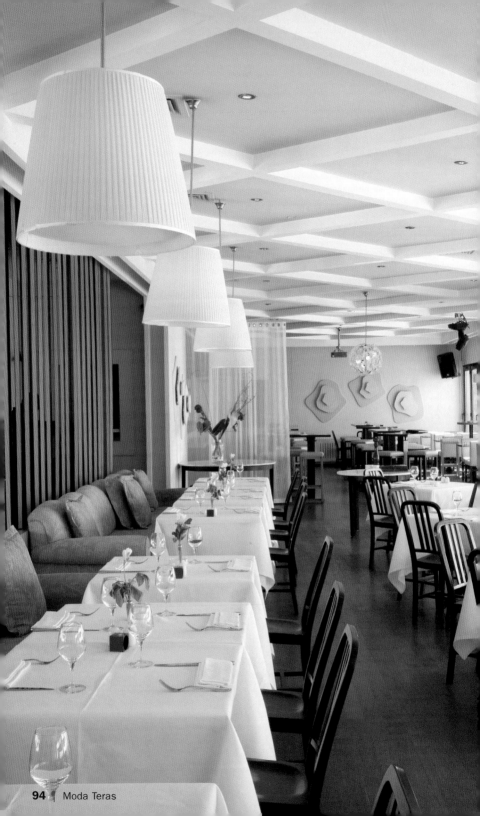

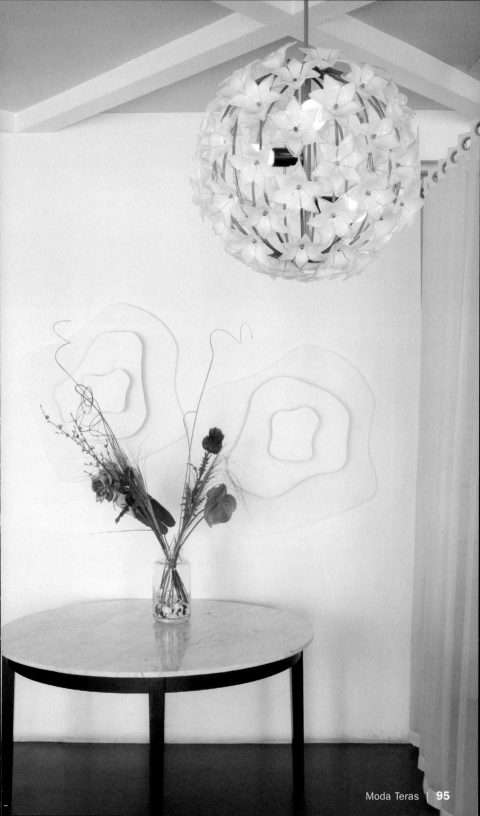

müzedechanga

Design: Autoban, Seyhan Özdemir, Sefer Çağlar
Chef: Changa Team, Peter Gordon
Owners: Savaş Ertunç, Tarık Bayazıt

Sakıp Sabancı Caddesi 22 | 34467 Istanbul | Emirgan
Phone: +90 212 323 0901
www.changa-istanbul.com
Opening hours: Tue–Sun 10:30 am to midnight, Mon closed
Cuisine: Turkish fusion
Special features: Located inside Sabancı Museum, view of the Bosporus

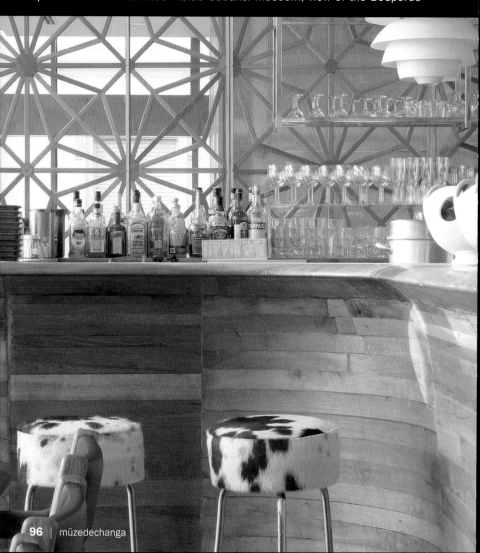

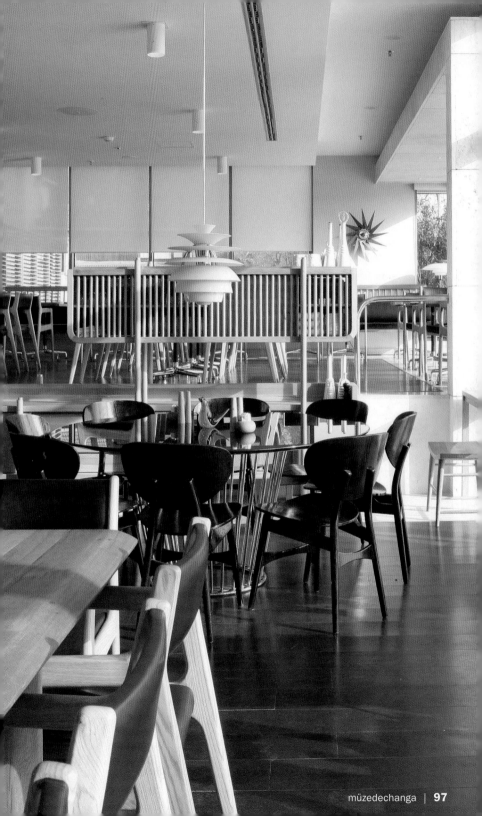

Pandeli

Chef: Nazım Telli, Süleyman Çelik
Owners: Cemal Biberci, Dr. Hristo Çobanoğlu

Mısır Çarşısı 1 | 34116 Istanbul | Eminönü
Phone: +90 212 522 5534
www.pandeli-restaurant.com
Opening hours: Mon–Sat 11:30 am to 3:30 pm, Sun closed
Average price: 19 YTL
Cuisine: Ottoman

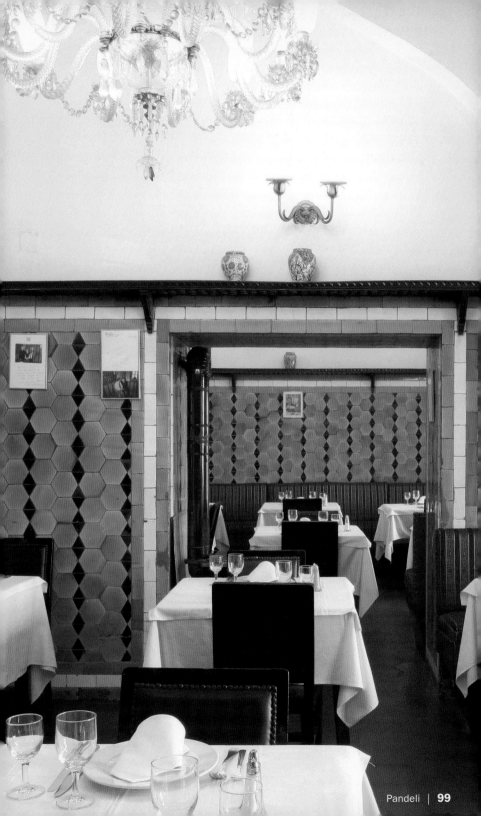

Paper Moon

Design: Tony Chi | Chef: Guiseppe Pressani

Ahmet Adnan Saygun Caddesi, Akmerkez | 34337 Istanbul | Ulus
Phone: +90 212 282 1616
Opening hours: Everyday noon to 1:30 am
Average price: 50 YTL
Cuisine: Italian
Special features: Bar and lounge

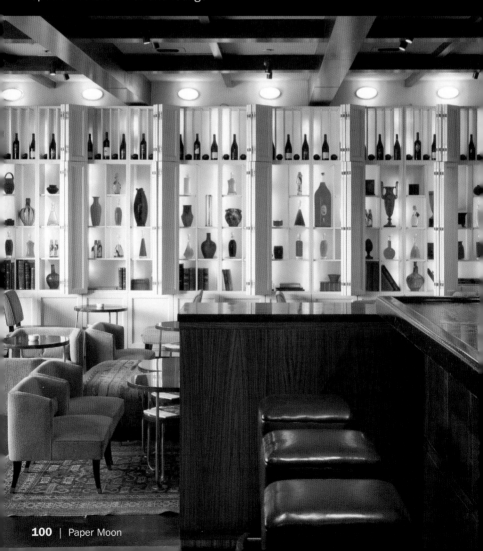

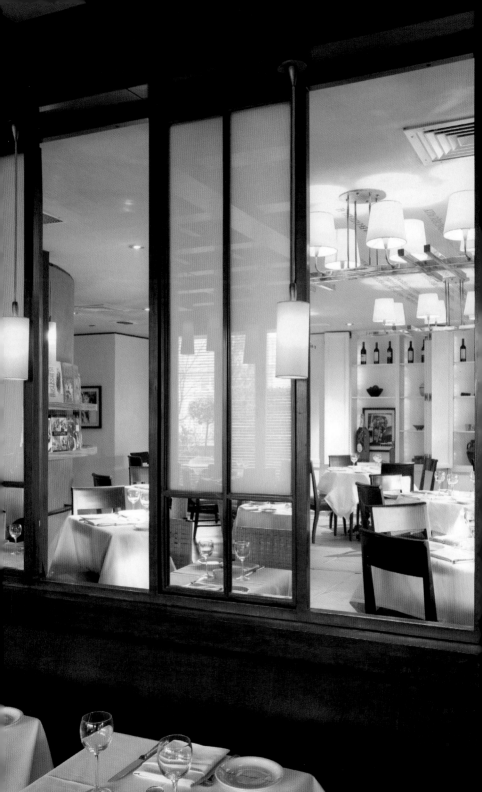

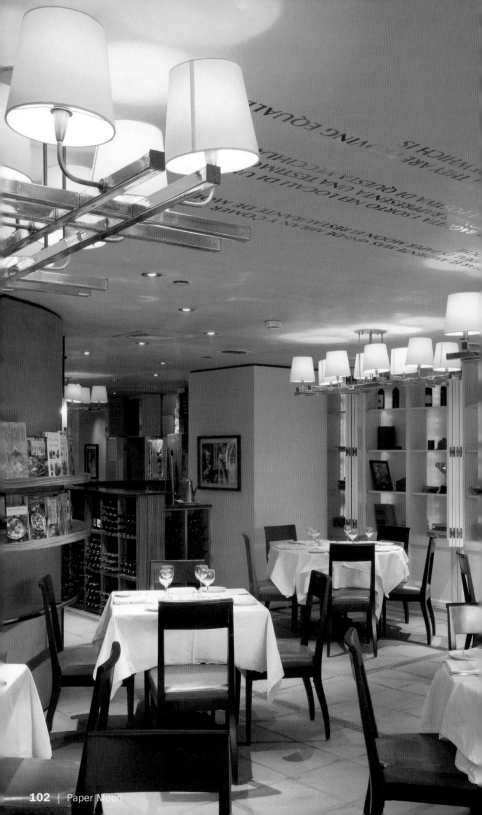

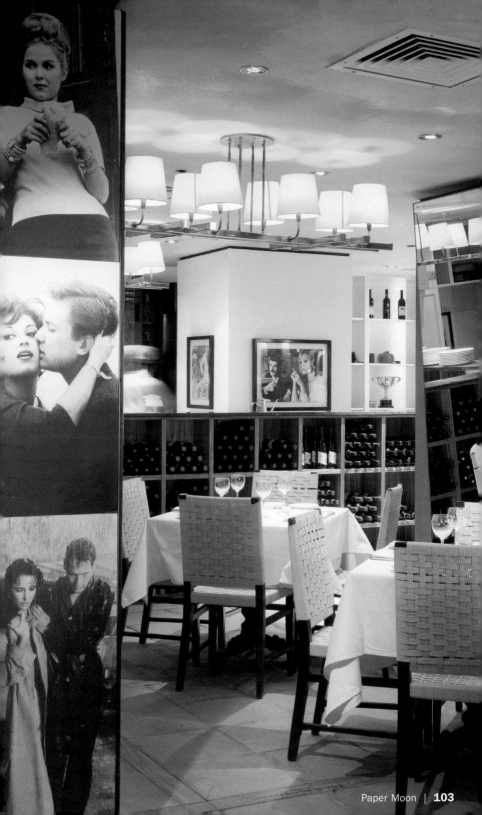

Park Samdan

Design: Bülent Erbaşar | Chef: Hıdır Alıcı | Owner: Ersoy Çetin

Mim Kemal Öke Caddesi 18/1 | 34367 Istanbul | Nişantaşı
Phone: +90 212 225 0710
Opening hours: Mon–Sat 12:30 pm to 3:30 pm, 7:30 pm to midnight, Sun closed
Average price: 28 YTL
Cuisine: Turkish, French

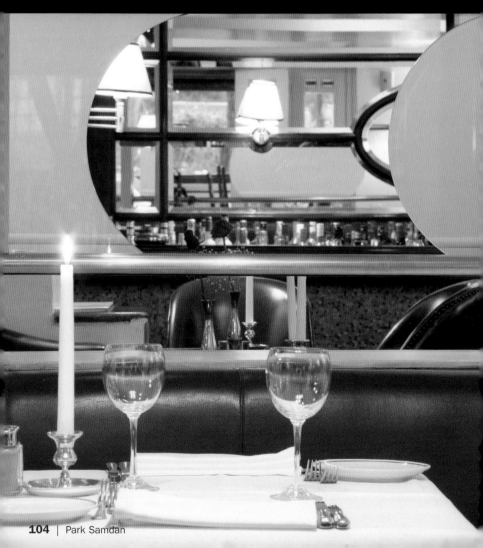

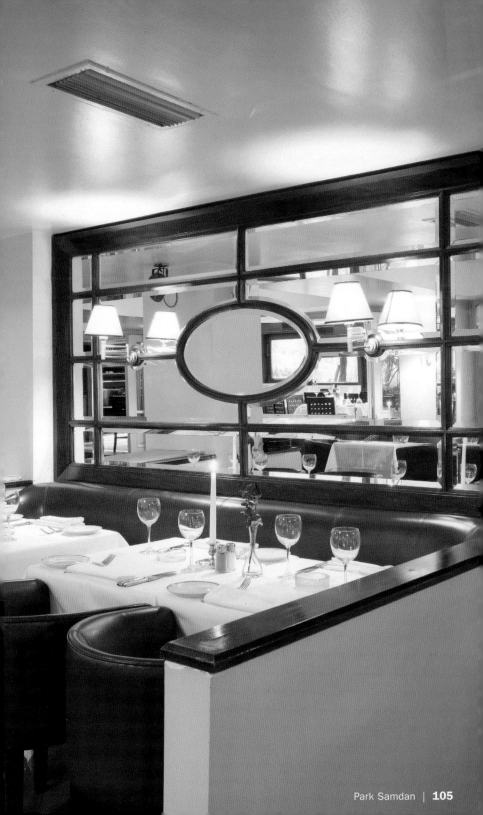

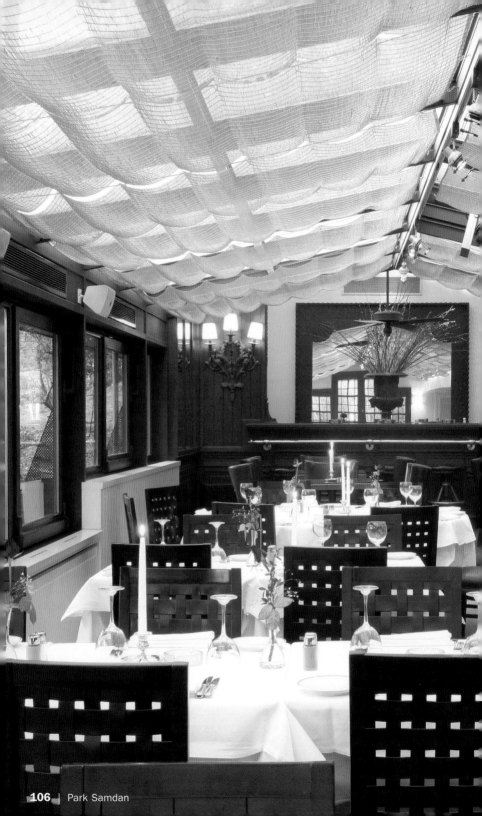

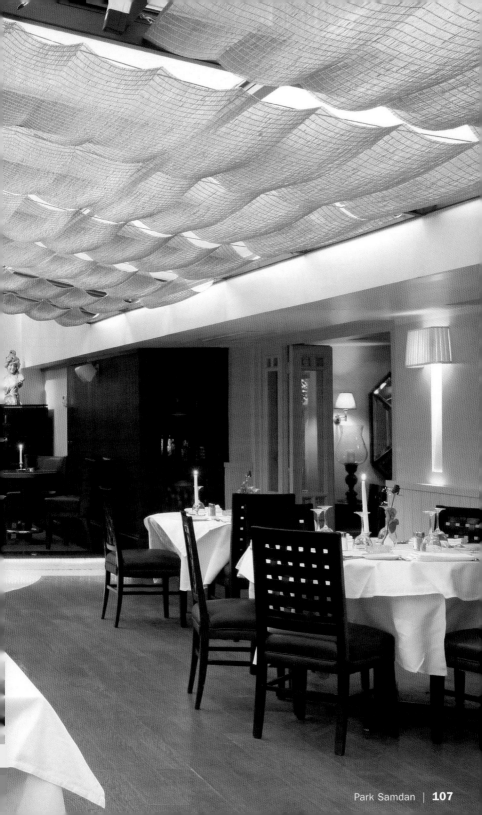

Sunset Grill & Bar

Design: Aykut Dokur | Chef: Hüseyin Arslan
Owner: Barış Tansever

Adnan Saygun Caddesi Yol Sokak 2 | 34340 Istanbul | Ulus
Phone: +90 212 287 0357
sunsetgrillbar@superonline.com
Opening hours: Mon–Sat noon to 3 pm, 6 pm to 1 am, Sun 6 pm to 1 am
Average price: 35 YTL
Cuisine: International
Special features: In summer terrace with view

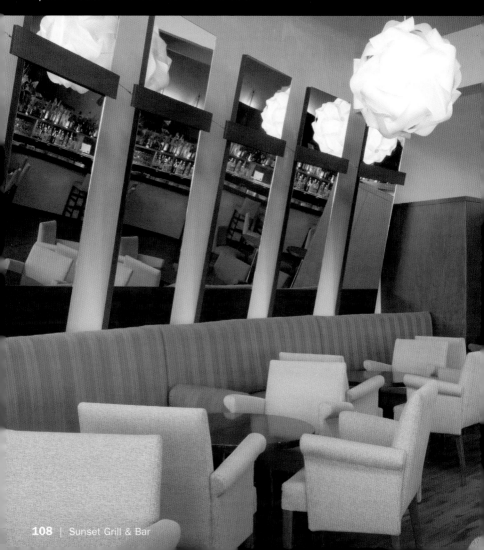

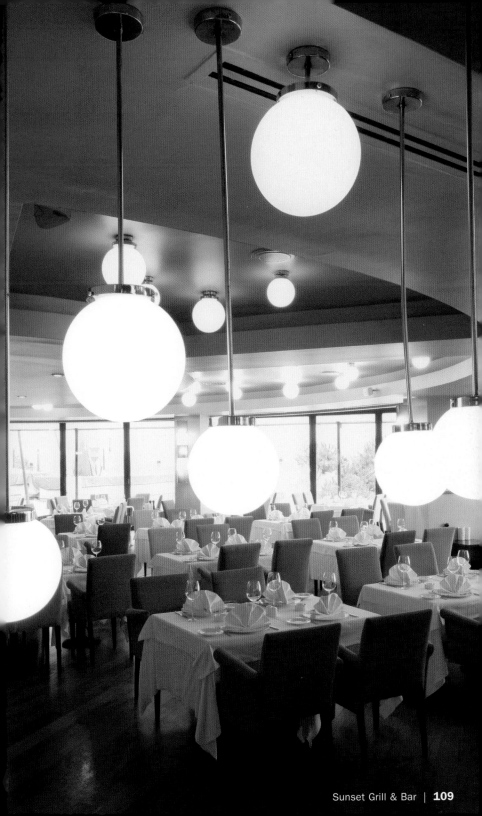

Yufka Wrapped Prawns

In Yufka gerollte Garnelen
Langoustines en rouleaux de yufka
Langostinos enrollados en Yufka
Rotoli di gamberi in pasta yufka

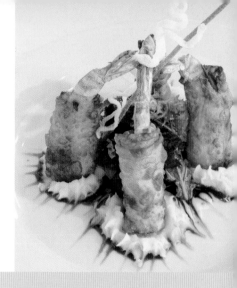

4 sheets of yufka dough, quartered
16 medium sized prawns, cleaned
2 medium carrots, in julienne
2 zucchini, in julienne
4 tbsp soy bean sprouts
4 dried tomatoes, diced
2 tbsp butter
Salt, pepper
1 egg white
Sunflower oil for deep-frying

Sauté the vegetables in butter and season. Wrap together with one prawn into each sheet of yufka and glue the edges together with egg white. Deep-fry in 320 °F hot oil for approx. 4 minutes. Serve with salad.

4 Yufka-Teigblätter, geviertelt
16 mittelgroße Garnelen, geputzt
2 mittlere Karotten, in Julienne
2 Zucchini, in Julienne
4 EL Sojasprossen
4 getrocknete Tomaten, gewürfelt
2 EL Butter
Salz, Pfeffer
1 Eiweiß
Sonnenblumenöl zum Frittieren

Die Gemüse in Butter anschwitzen und würzen. Zusammen mit je einer Garnele in ein gevierteltes Yufka-Blatt einwickeln und die Ränder mit Eiweiß zukleben. In 160 °C heißem Öl ca. 4 Minuten frittieren. Mit Salat servieren.

4 feuilles de yufka coupées en quatre
16 langoustines de taille moyenne, décortiquées
2 carottes de taille moyenne en julienne
2 courgettes en julienne
4 c. à soupe de pousses de soja
4 tomates séchées en dés
2 c. à soupe de beurre
Sel, poivre
1 blanc d'œuf
Huile de tournesol pour la friture

Faire revenir les légumes dans le beurre et assaisonner. Les enrouler avec respectivement une langoustine dans un quart de feuille de yufka et coller les bords au blanc d'œuf. Les frire dans l'huile bouillante à 160 °C pendant env. 4 minutes. Servir avec de la salade.

4 láminas de masa de Yufka en cuartos
16 langostinos limpios de tamaño mediano
2 zanahorias medianas en juliana
2 calabacines en juliana
4 cucharadas de brotes de soja
4 tomates secos troceados
2 cucharadas de mantequilla
Sal y pimienta
1 clara de huevo
Aceite de girasol para freír

Sofreír la verdura en mantequilla y salpimentarla. Enrollar un langostino con verdura en cada lámina de Yufka y cerrar los bordes cubriéndolos con clara de huevo. Freír los rollos en aceite a 160 °C durante 4 minutos. Servirlos con ensalada.

4 fogli di pasta yufka tagliati in quattro
16 gamberi di grandezza media puliti
2 carote non troppo grandi tagliate a julienne
2 zucchini tagliati a julienne
4 cucchiai di germogli di soia
4 pomodori secchi tagliati a dadini
2 cucchiai di burro
Sale, pepe
1 albume d'uovo
Olio di semi di girasole per friggere

Dorare nel burro le verdure e condirle. Arrotolarle insieme ad un gambero in un foglio di pasta yufka tagliato in quattro ed incollarne i bordi con l'albume d'uovo. Friggere per circa 4 minuti in olio caldo a 160 °C. Servire con contorno di insalata.

Sushi-Co

Design: Page Mimarlık, Zeynep Sayın | Chef: Zhu Shandi, Paya Yavas, Sumit Jandad | Owners: Selim Yalın, Baran Dumanoğlu, Oğuz Dumanoğlu, Ayhan Şekeroğlu

İstiklal Caddesi 445 | 34433 Istanbul | Tünel
Phone: +90 212 243 8765
www.chineseintown.com
Opening hours: Sun–Thu noon to midnight, Fri–Sat noon to 2 am
Average price: 15 YTL
Cuisine: Sushi, Chinese, Thai

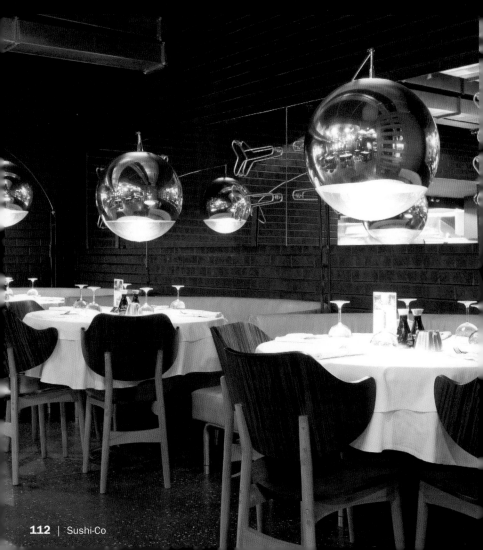

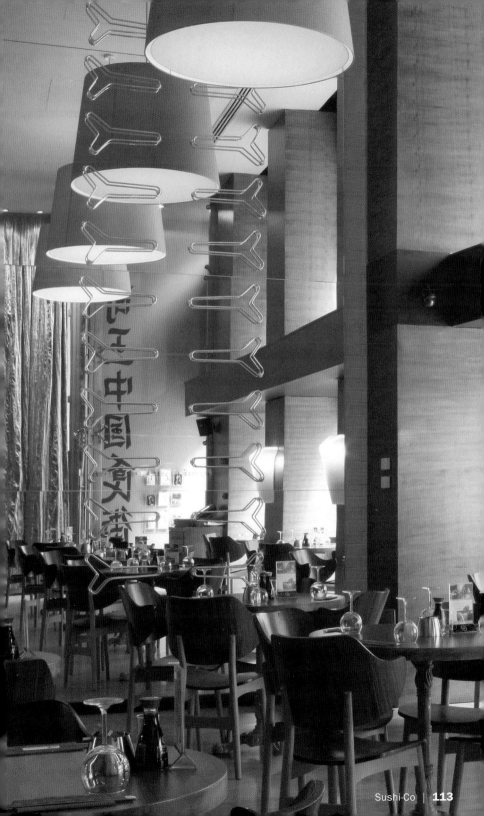

Grilled Salmon

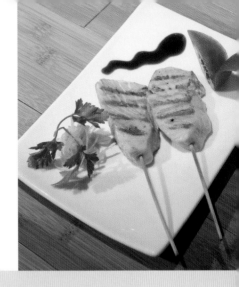

Gegrillter Lachs
Saumon grillé
Salmón a la plancha
Salmone alla griglia

8 pieces salmon fillet, 4 oz each
4 tbsp olive oil
2 tbsp fresh thyme, chopped roughly
1 tsp pepper, ground coarsely
8 tbsp teriyaki sauce
Juice of one lemon
Salt

Mix all ingredients for the marinade thoroughly and marinate the salmon fillets for at least 2 hours. Remove the salmon from the marinade and put each fillet on a stick. Grill on a small table grill on both sides for approx. 2 minutes and serve immediately.

8 Stücke Lachsfilet, à 125 g
4 EL Olivenöl
2 EL frischer Thymian, grob gehackt
1 TL Pfeffer, grob gemahlen
8 EL Teriyaki-Sauce
Saft einer Zitrone
Salz

Alle Zutaten für die Marinade gründlich mischen und die Lachsfilets mind. 2 Stunden darin marinieren. Den Lachs aus der Marinade nehmen und jedes Lachsfilet auf einen Holzspieß stecken. Auf einem kleinen Tischgrill am Tisch von jeder Seite ca. 2 Minuten grillen und sofort servieren.

8 morceaux de filet de saumon de 125 g chacun
4 c. à soupe d'huile d'olive
2 c. à soupe de thym frais, grossièrement haché
1 c. à café de poivre concassé
8 c. à soupe de sauce teriyaki
Le jus d'un citron
Sel

Bien mélanger tous les ingrédients pour la marinade et laisser les filets de saumon mariner au moins 2 heures. Retirer de la marinade et embrocher chaque filet sur une brochette en bois. Faire griller chaque côté env. 2 minutes sur un petit grill de table et servir immédiatement.

8 trozos de filete de salmón de unos 125 g
4 cucharadas de aceite de oliva
2 cucharadas de tomillo fresco, picado en grueso
1 cucharadita de pimienta molida en grueso
8 cucharadas de salsa Teriyaki
Zumo de 1 limón
Sal

Mezclar todos los ingredientes para marinar y dejar los filetes de salmón en la mezcla durante 2 horas al menos. Retirar el salmón del marinado y pasar una brocheta de madera por cada filete. Dorarlas por ambos lados unos 2 minutos en una plancha pequeña, colocada directamente sobre la mesa y servirlas al instante.

8 tranci di filetto di salmone di 125 g ciascuno
4 cucchiai di olio d'oliva
2 cucchiai di timo fresco tritato grossolanamente
1 cucchiaino di pepe macinato grosso
8 cucchiai di salsa teriyaki
Il succo di un limone
Sale

Mescolare bene tutti gli ingredienti e marinarvi i filetti di salmone per almeno 2 ore. Estrarre il salmone dalla marinata ed infilzare ogni filetto su uno spiedino di legno. Grigliarlo su un piccolo grill da tavolo per circa 2 minuti da ciascun lato e servire subito.

The House Café

Design: Autoban, Seyhan Özdemir, Sefer Çağlar, Efe Aydar
Chef: Coşkun Uysal | Owners: Ramazan Üren,
Canan & Ferit Baltacıoğlu

Salhane Sok 1 | 34347 Istanbul | Ortaköy
Phone: +90 212 227 2699
www.thehousecafe.com.tr
Opening hours: Everyday 9 am to 2 am
Average price: 17 YTL
Cuisine: English, Italian, Turkish
Special features: There are also branches in Nişantaşı and Taksim

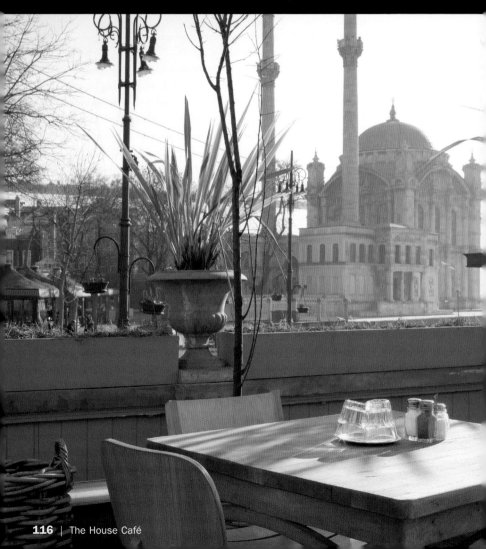

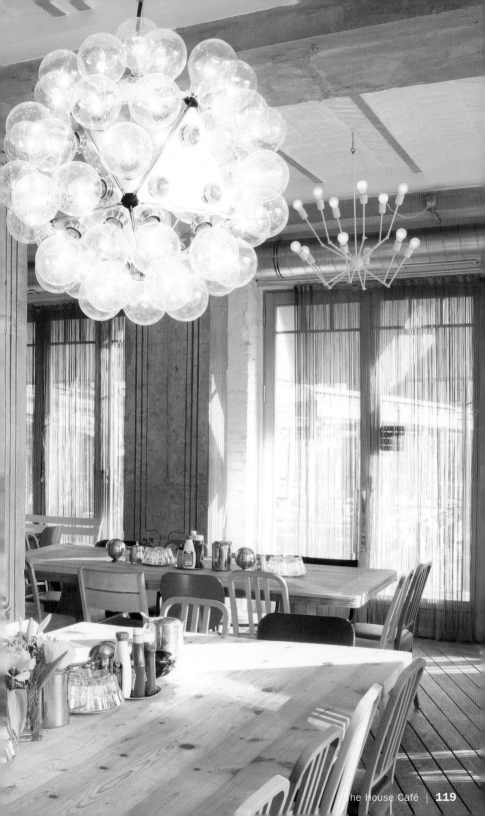

Tuğra

Design: Hande Akın Tozun | Chef: Ugur Alparslan
Owner: Çirağan Palace Hotel Kempinski

Çirağan Caddesi 32 | 34349 Istanbul | Beşiktaş
Tel: +90 212 326 4646
www.ciragan-palace.com
Opening hours: Everyday 7 pm to 11 pm
Average price: 150 YTL
Cuisine: Turkish
Special features: Classic Turkish music (fasıl)

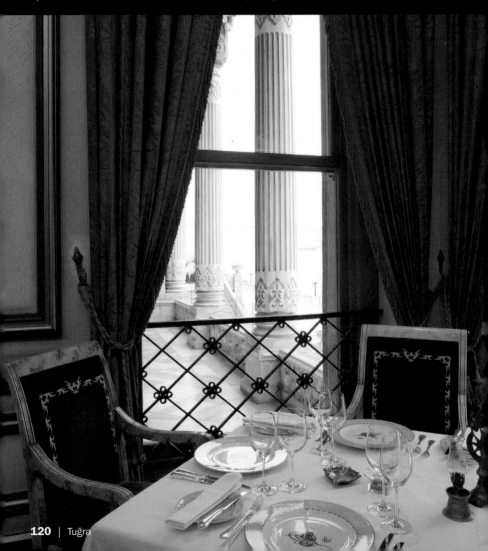

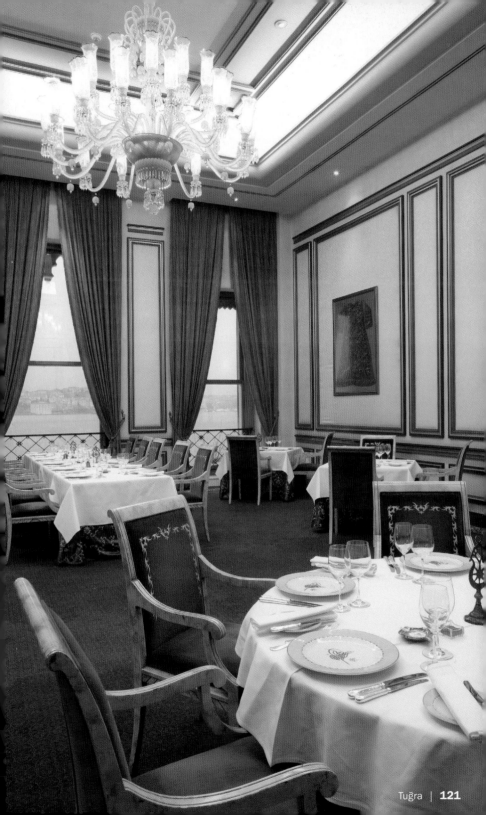

Charcoal Grilled Loin of Lamb

Lammlende vom Holzkohlegrill

Filet d'agneau grillé au charbon de bois

Lomo de cordero en plancha de carbón vegetal

Lombata di agnello alla griglia

1 lb 4½ oz loin of lamb, cleaned
2 tsp salt
2 tsp pepper, ground
2 tbsp fresh oregano, chopped
1 tbsp rosemary, chopped
1 tbsp cumin, ground
1 tbsp paprika powder
160 ml olive oil

Cut the lamb meat into 12 pieces, combine all ingredients and marinate the meat overnight in the refrigerator.

8¾ oz Firik rice
750 ml vegetable stock
5¼ oz butter
4 tbsp sunflower oil
Salt, pepper

Wash the rice a couple of times and drain well, combine all ingredients, bring to a boil and let simmer gently for 20 minutes.
Grill the lamb meat on both sides for 4 minutes on a charcoal grill, wrap in aluminum foil and let rest for 8 minutes. Serve with Firik rice and different vegetables.

600 g Lammlende, pariert
2 TL Salz
2 TL Pfeffer, gemahlen
2 EL frischer Oregano, gehackt
1 EL Rosmarin, gehackt
1 EL Kreuzkümmel, gemahlen
1 EL Paprikapulver
160 ml Olivenöl

Das Lammfleisch in 12 Stücke schneiden, alle Zutaten miteinander mischen und das Fleisch über Nacht im Kühlschrank marinieren lassen.

250 g Firik-Reis
750 ml Gemüsebrühe
150 g Butter
4 EL Sonnenblumenöl
Salz, Pfeffer

Den Reis mehrmals waschen und gut abtropfen lassen, alle Zutaten miteinander mischen, einmal aufkochen und 20 Minuten leise köcheln lassen.
Das Lammfleisch auf dem Holzkohlegrill von beiden Seiten jeweils 4 Minuten grillen, in Aluminiumfolie wickeln und 8 Minuten ruhen lassen. Mit Firik-Reis und verschiedenen Gemüsen servieren.

600 g de filet d'agneau paré
2 c. à café de sel
2 c. à café de poivre moulu
2 c. à soupe d'origan frais haché
1 c. à soupe de romarin haché
1 c. à soupe de cumin moulu
1 c. à soupe de paprika en poudre
160 ml d'huile d'olive

Couper l'agneau en 12 morceaux, mélanger tous les ingrédients et laisser mariner la viande une nuit au réfrigérateur.

250 g de riz pilaf
750 ml de bouillon de légumes
150 g de beurre
4 c. à soupe d'huile de tournesol
Sel, poivre

Laver le riz plusieurs fois et bien l'égoutter. Mélanger tous les ingrédients, amener à ébullition et laisser frémir 20 minutes à feu doux. Faire griller l'agneau sur le grill au charbon de bois env. 4 minutes de chaque côté, envelopper les morceaux dans une feuille d'aluminium et laisser reposer 8 minutes. Servir avec du riz pilaf et des légumes variés.

600 g de lomo de cordero limpio
2 cucharaditas de sal
2 cucharaditas de pimienta molida
2 cucharadas de orégano fresco picado
1 cucharada de romero picado
1 cucharada de cominos molidos
1 cucharada de pimentón
160 ml de aceite de oliva

Cortar la carne de cordero en 12 trozos, mezclar todos los ingredientes y dejar la carne en el marinado durante una noche dentro del frigorífico.

250 g de arroz Firik
750 ml de caldo de verdura
150 g de mantequilla
4 cucharadas de aceite de girasol
Sal y pimienta

Lavar el arroz varias veces y escurrirlo bien. Mezclar todos los ingredientes, llevarlos a ebullición y dejarlos cocer a fuego lento durante 20 minutos. En la plancha de carbón, asar la carne 4 minutos por cada cara, envonverla en papel de aluminio y dejarla reposar durante 8 minutos. Servirla con el arroz Firik y verduras varias.

600 g di lombata di agnello parata
2 cucchiaini di sale
2 cucchiaini di pepe macinato
2 cucchiai di origano fresco tritato
1 cucchiaio di rosmarino tritato
1 cucchiaio di cumino macinato
1 cucchiaio di paprica in polvere
160 ml di olio d'oliva

Tagliare la carne di agnello in 12 pezzi, mescolare tutti gli ingredienti e marinarvi la carne in frigorifero per una notte.

250 g di riso firik
750 ml di brodo di verdure
150 g di burro
4 cucchiai di olio di semi di girasole
Sale, pepe

Lavare più volte il riso e sgocciolarlo bene. Mescolare tutti gli ingredienti, portarli a cottura e lasciarli cuocere a fuoco lento per 20 minuti. Grigliare la carne sulla carbonella per 4 minuti da entrambi i lati, avvolgerla in un foglio di alluminio e lasciarla riposare per 8 minuti. Servire con riso firik e verdure miste.

Ulus 29

Design: Zf design, Zeynep Fadıllıoğlu | Chef: Pierre Levi
Owner: Metin Fadıllıoğlu

Ahmat Adnan Saygun Caddesi, Ulus Parkı İçi 1 | 34340 Istanbul | Ulus
Phone: +90 212 358 2929
www.club29.com
Opening hours: Everyday noon to 4 am
Average price: 45 YTL
Cuisine: Turkish, sushi
Special features: Lounge, night club (Club 29) with DJ performance

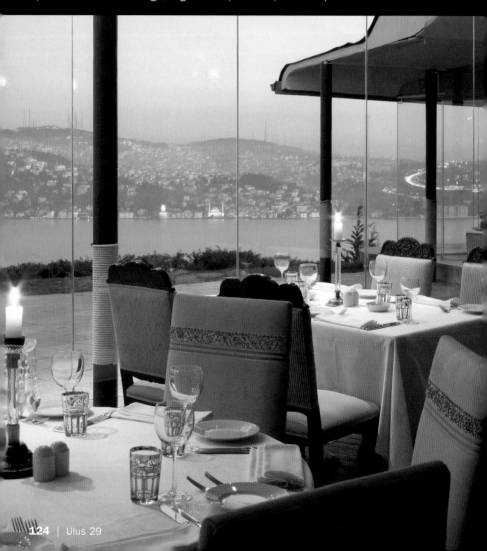

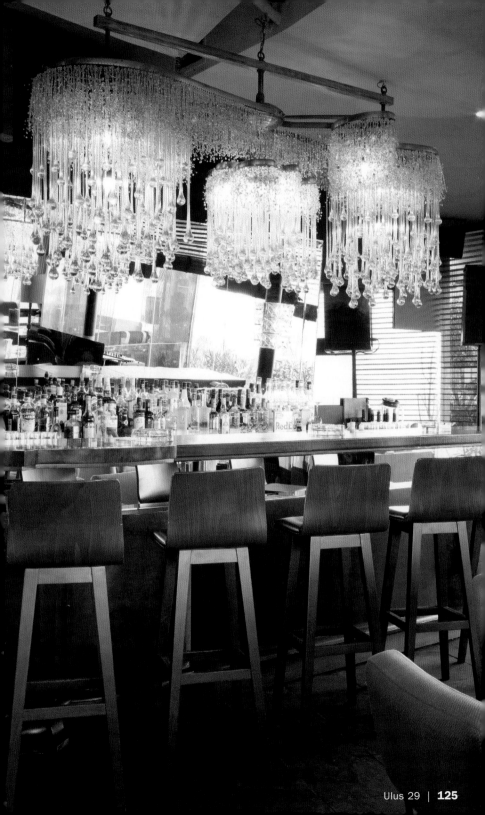

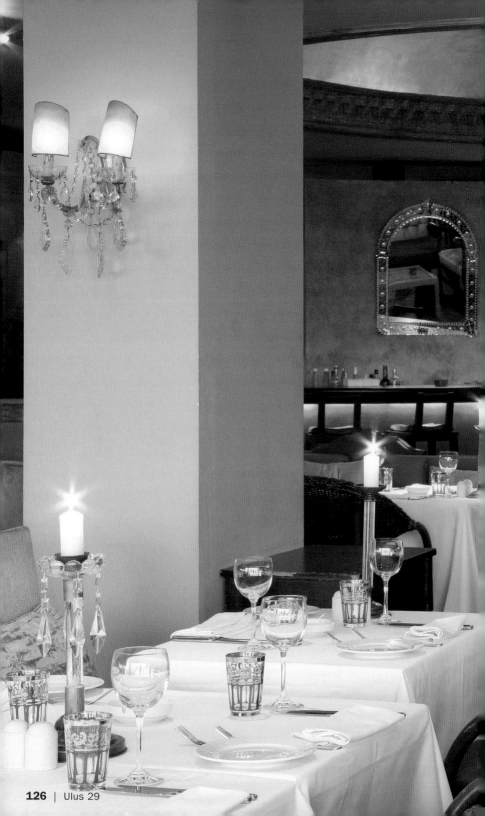

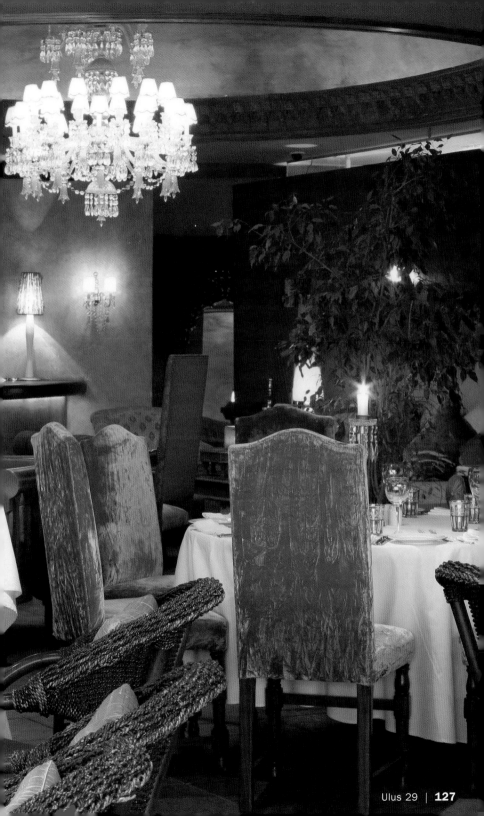

Vogue

Design: Geomim, Mahmut Anlar | Chef: Talip Çalışkan
Owner: Istanbul Doors Restaurant Group

Spor Caddesi BJK Plaza A Blok K.13 Akaretler | 34357 Istanbul | Beşiktaş
Phone: +90 212 227 4404
www.istanbuldoors.com
Opening hours: Mon–Sat noon to 2 am, Sun 10:30 am to 4 pm
Average price: 30 YTL
Cuisine: Mediterranean, sushi
Special features: Brunch on Sundays

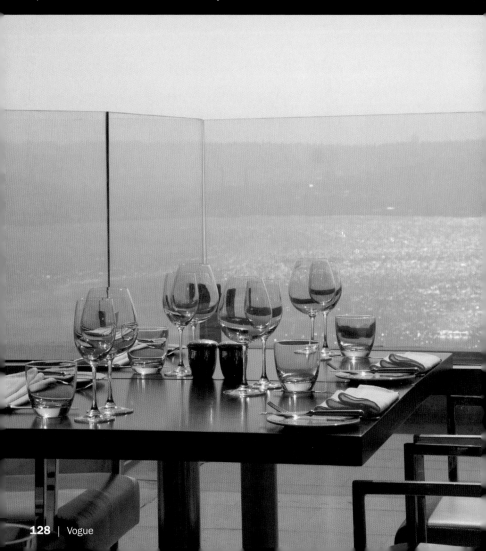

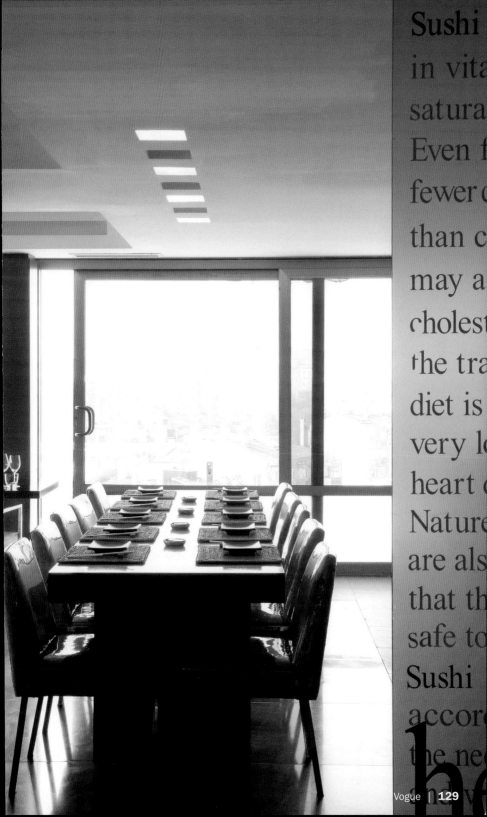

Sushi
in vita
satura
Even f
fewer
than c
may a
cholest
the tra
diet is
very l
heart
Nature
are als
that th
safe to
Sushi
accor
the ne
h

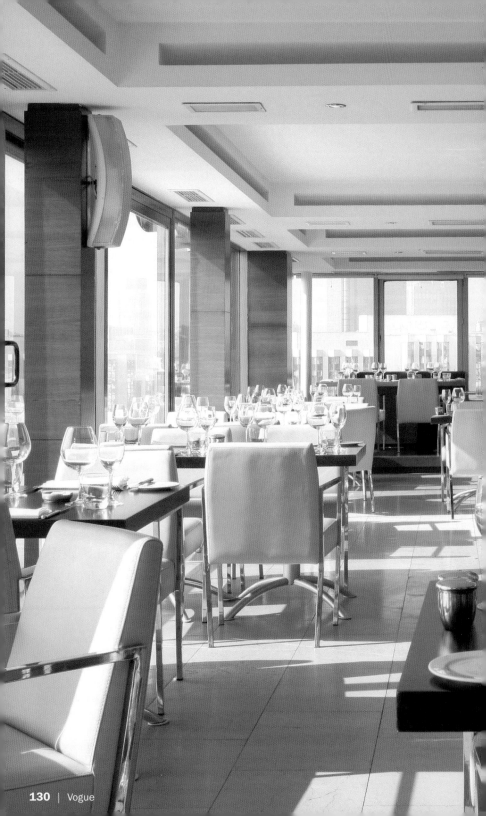

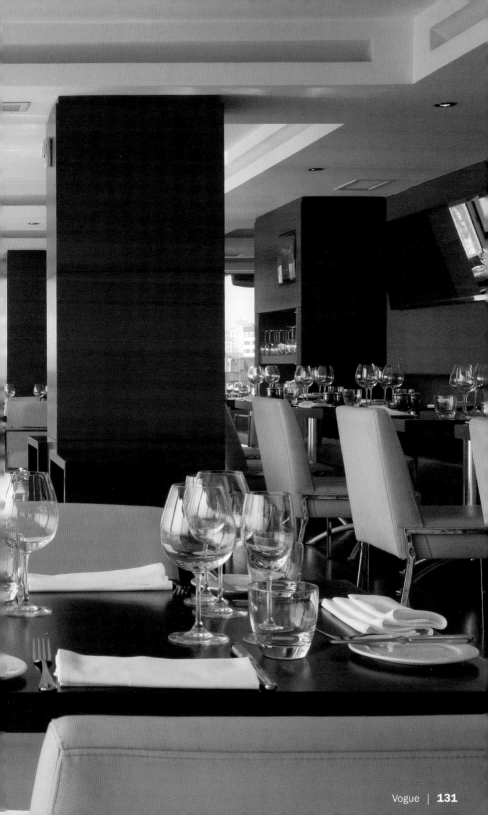

Wan-na

Design: Geomim, Mahmut Anlar, N. Sinan Erül
Chef: Nihat Sancar | Owner: Istanbul Doors Restaurant Group

Meşrutiyet Caddesi 151 | 34430 Istanbul | Tepebaşı
Phone: +90 212 243 1794
www.istanbuldoors.com
Opening hours: Mon–Sat noon to 2 am, Sun 6 pm to 2 am, holidays Jun to Oct
Average price: 30 YTL
Cuisine: Eastern, Thai
Special features: DJ performance everyday, night club

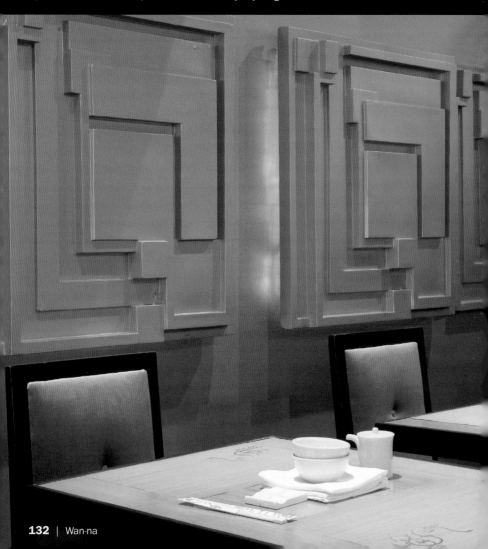

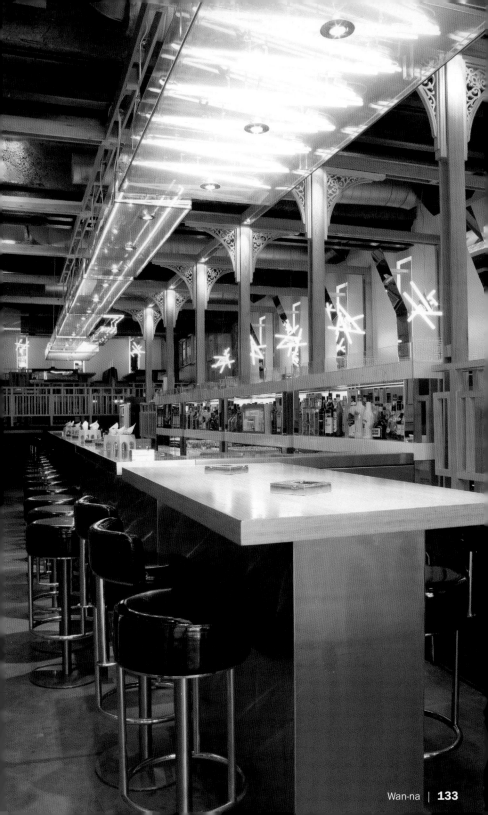

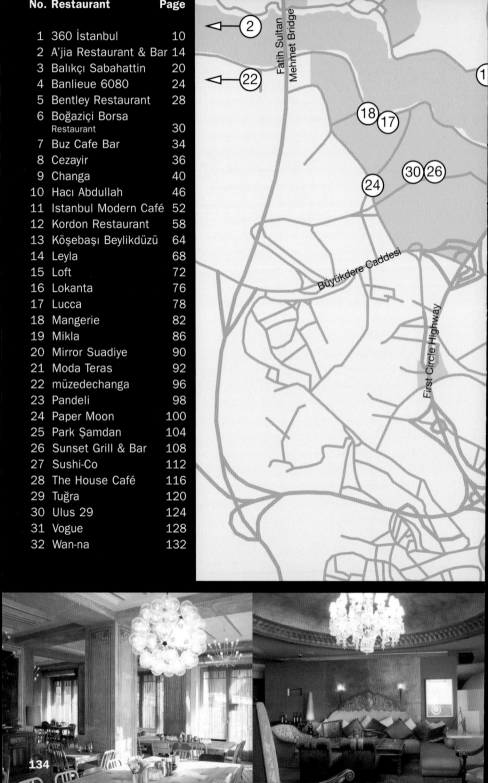

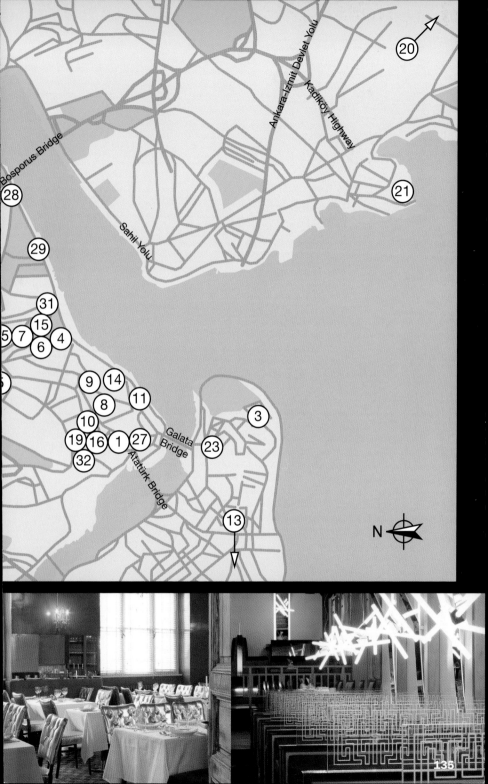

Cool Restaurants

Size: 14 x 21.5 cm / $5^1/2$ x $8^1/2$ in.
136 pp, Flexicover
c. 130 color photographs
Text in English, German, French,
Spanish, Italian or (*) Dutch

Other titles in the same series:

teNeues